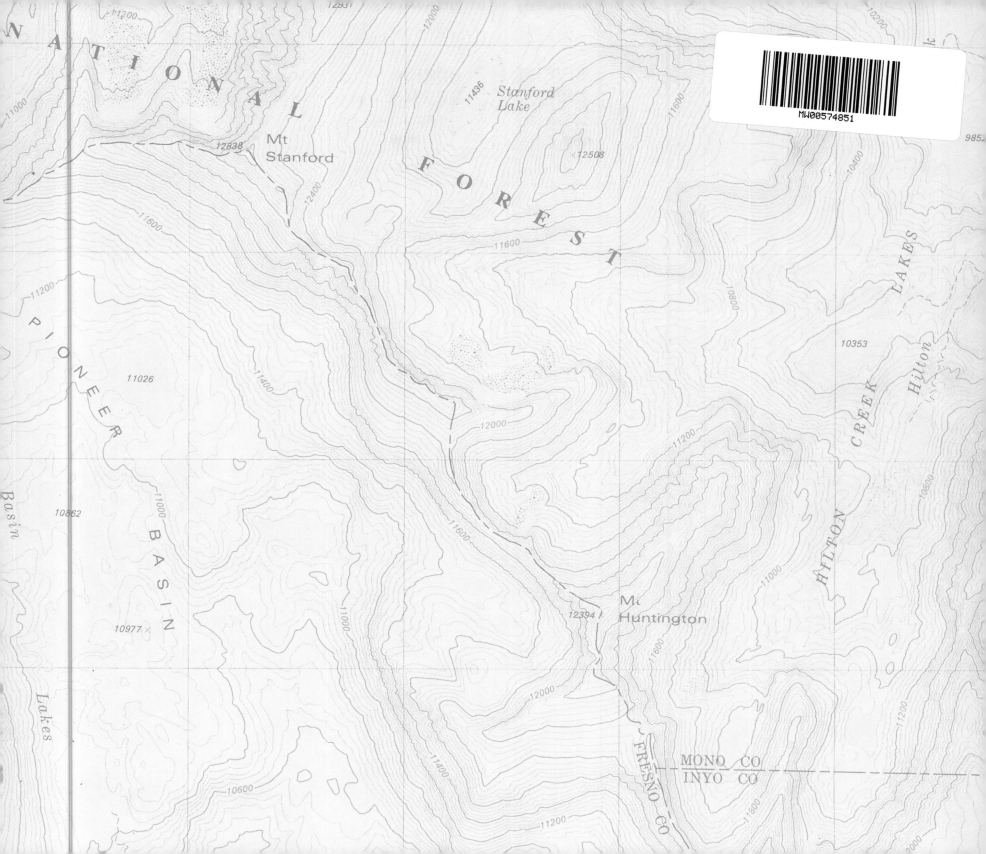

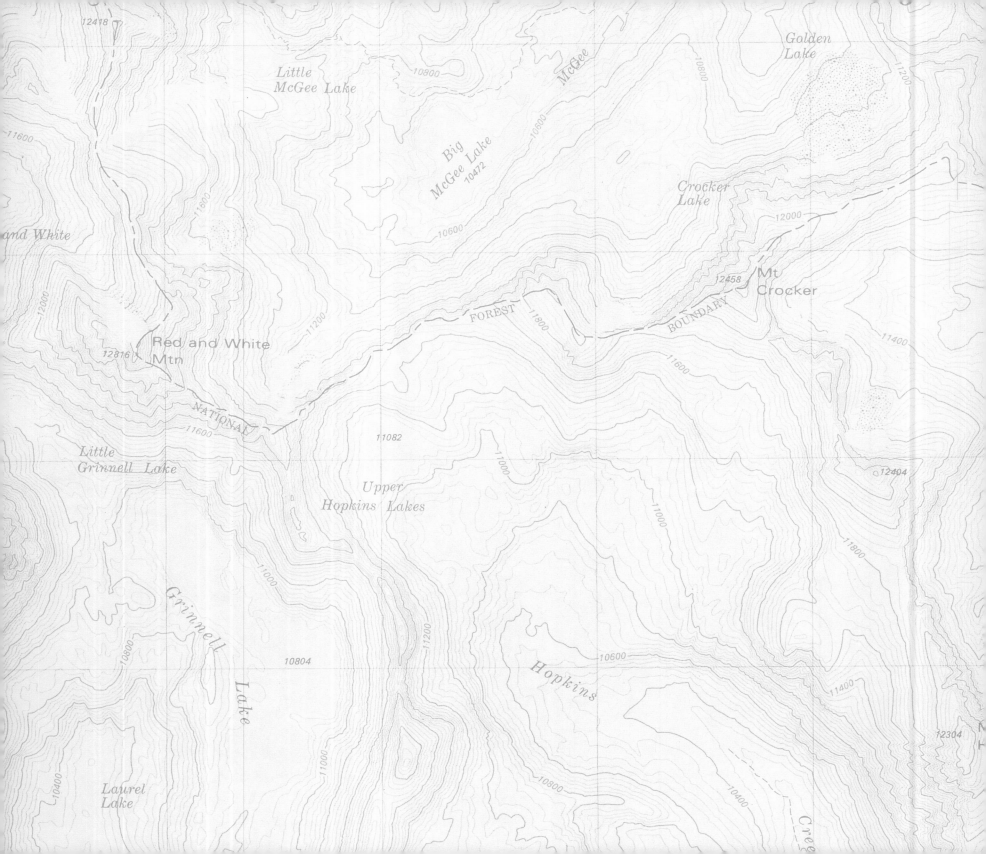

THE HIGH SIERRA

The High Sierra

WILDERNESS OF LIGHT

CLAUDE FIDDLER

Introduction by Steve Roper
Foreword by David Brower

CHRONICLE BOOKS

SAN FRANCISCO

Printed in Hong Kong

Fiddler, Claude.
 The high sierra: wilderness of light / by Claude Fiddler, Steve Roper, and David Brower.
 p. cm.
 Includes bibliographical references (p.).
 ISBN 0-8118-0970-6
 1. Sierra Nevada (Calif. and Nev.)--pictorial works.
 2. Sierra Nevada (Calif. and Nev.)--Tours.
 I. Roper, Steve II. Brower, David Ross, 1912 III. Title.
 F868.S5F52 1995
 979.4'4'00222--dc20 94-39678
 CIP

Distributed in Canada by Raincoast Books
8680 Cambie Street, Vancouver, B.C. V6P 6M9

10 9 8 7 6 5 4 3 2 1

Chronicle Books
275 Fifth Street
San Francisco, CA 94103

Claude Fiddler's photographs take me back sixty-two years to my first backpack trip in the High Sierra, from the Palisades to Yosemite in 1933. I was only twenty-one, but those seven weeks of wandering along the Sierra crest with George Rockwood stay with me still; time has not dimmed the delights of that journey. Half a century later George recalled it as the high point of his life.

Memories often come in pairs. If you remember one thing, its companion pops up too; the lyrics bring back the tune. It is amazing what pops back into my mind's gallery when I turn Claude's pages. I can see and almost taste exactly what George and I ate, still remember the songs we sang, if not our conversations, when a picture reminds me of a lake we paused by or the garden we camped in. As Li Po wrote so long ago, "We never grow tired of each other, the mountain and I."

Each page evokes a memorable Sierra event. One particular summit view brings back the afternoon on the Thumb when I put all my trust into a handhold that didn't deserve it, and I narrowly escaped a terminal fall that would have suggested that the Sierra *had* grown tired of me.

The air was clearer in those days. From Sierra summits we could almost always see the Coast Range. Today we see the air more often than we see through it. Back in the thirties we could camp anywhere, drink from any of the high streams, delight in the warmth offered by plentiful firewood and the friendships we shared. Only the friendships remain.

What other memories do these photographs bring back? High camps in the company of whitebark pines, nearby streams where we drank, sleeping bag sites with natural hip holes in the duff, pine-branch silhouettes to screen us from too much moonlight or too many stars, or to support a scanty tarp if it rained (of course, it never rains at night in the Sierra). Rugged walls and summit profiles that challenged us to go for the top or for the knapsack passes to escape the drudgery of the trails.

Some of these memories may not be universally shared. But Claude resuscitates one known to almost all of us: a sky that brings natural light to a world that wildness has made perfect, especially the rare light of early morning, or the last light and alpenglow no one could cease to marvel at.

These photographs, besides reminding us of what we never intended to forget, also testify to the work of hosts of people who have helped keep these places what they are. Many of them were the wilderness explorers of the Sierra Club, joined by countless individuals who fought to preserve the range from those who would trash it and those who still need to be shown better things to do. They can keep themselves busy by seizing the opportunity to conserve, preserve, and restore the only planet we are ever likely to live on, the only planet ever to know the gentle wilderness of the Sierra Nevada.

In his skillful matching of text to image, Steve Roper has created a mood that evokes not only the uniqueness of the high country, but also the affection our predecessors had for it. Today we cannot match their enthusiasm, because there are no longer blank places on the map, or new routes along streams or up over unexplored passes and the virgin vistas they revealed. Too bad. But if we listen carefully, we can almost hear one of them call out to another, "Gad! Wait till you see this!"

Such surprises need not be a thing of the past. Just pretend you're the first person to cross the pass. The experience will almost be the same, so long as we let wild ecosystems manage themselves. They've had a lot of practice. Let them remain an essential part of what Wallace Stegner called "the geography of hope."

There the sentient beings of the future can explore, enjoy, and protect the music of mountain streams, the stimulus of a challenging mountain wall or high point, and the magic that happens when the last rays of sun set a distant summit afire.

Claude Fiddler continues the tradition begun by Joseph N. LeConte and carried on, each in his own way, by Ansel Adams, Cedric Wright, Philip Hyde, and Richard Kauffman. We'll be grateful to all of them for a long time.

Thank you, Claude and Steve, for the memories.

David Brower,
Berkeley,

1994

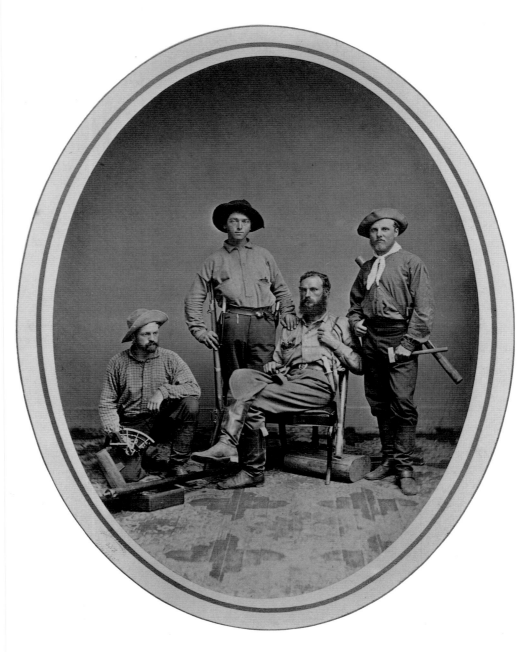

CALIFORNIA GEOLOGICAL SURVEY, 1863

Unknown surveyor, Richard Cotter, William Brewer, and Clarence King

BY STEVE ROPER

*T*he heart of California's Sierra Nevada remains as pristine as it was a century ago, when curious men and women ventured into the unknown portion of the range. The High Sierra, a two-thousand-square-mile region brimming with lakes, cirques, and jagged granite peaks, is untrammeled because it is still out of reach of the clutches of civilization. The photographs in this book, all taken by Claude Fiddler, portray this vast wilderness almost exactly as the pioneers saw it. No roads, no trails, no buildings, no campfire rings—just sky, rock, water, and a timberline region of austere beauty. The pioneers would revel in this book—and they would find few surprises.

Fiddler, a modern-day trailblazer (he made many first ascents of Sierra walls in his youth), has long been fascinated with the history of the range. His images show his love of the landscape and his appreciation of the pioneers' world, a universe of the purest beauty. Those who first wrote about the High Sierra regarded it as a temple where the spirit was free to soar. Fiddler has followed in the footsteps of the pioneers, both literally and figuratively.

The quotations placed opposite this book's photographs amply demonstrate that the pioneers were educated and eloquent—and often so enthusiastic that they lapsed into hyperbole. Who were these spirited people who wandered up and down the High Sierra a century ago? What were they like and where did they explore? The following narrative wanders through the annals of Sierra history, touching on six of the all-time great explorers and their trials, tribulations, and wild successes as they discovered the pristine wilderness called the High Sierra.

CLARENCE KING

*N*ative Americans lived in the foothills of the range, of course, and even crossed it on occasion; arrowhead-making sites have been discovered in the high country. But since these quiet wanderers left no written records, we will never know exactly where they (or the Spaniards of the eighteenth century) explored. Sheepherders and prospectors also knew many of the valleys on the gentle western flank of the great mountain uplift, but they rarely ventured onto the rocky heights—or at least left no records if they did so. Thus, the honor of being the first noteworthy Sierra explorer falls to the young geologist Clarence King.

Upon graduating from the Yale Scientific School, King came west to work with the California Geological Survey as this organization began charting the unknown regions of the state. The coastal strip, the Central Valley, and the Mother Lode were well-known locales by the 1860s, but the Sierra Nevada was a blank on the map—especially the wild, interior heart of the range, a region lying above 9,000 feet and measuring about one hundred and thirty miles long by fifteen miles wide.

In July 1864, a small group of geologists, surveyors, and mapmakers, including Clarence King, worked its way toward the Great Western Divide, a massive sub-range lying west of the main Sierra crest. William Brewer, the field leader of the Survey, climbed a conspicuous, pyramidal peak with a companion; from the top of this towering mountain—immediately named Mount Brewer—the two were captivated by

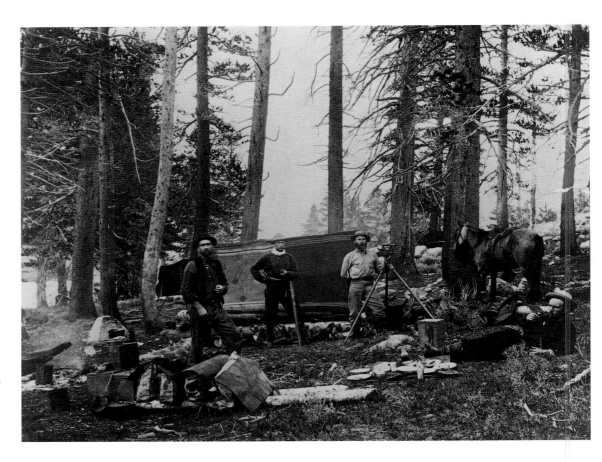

*California Geological Survey
at Tuolomne Meadows, 1863*

the endless array of spires, canyons, and cirques to the east. Taking advantage of the bird's-eye view, Brewer named many of the most prominent peaks, including one massive landform fourteen miles to the southeast: Mount Whitney. This mountain, named for the director of the Survey, seemed to be the Sierra's loftiest point.

Back in camp, the two climbers related the day's adventures to the others. The vision of such high, unexplored peaks rising only a few miles away proved too much for Clarence King to bear. The twenty-two-year-old geologist begged Brewer to let him attempt one of the huge peaks, preferably Whitney itself. Brewer, having taken note of the chaotic landscape lying between Mount Brewer and the Whitney massif, gave his permission reluctantly.

King and his companion, packer Richard Cotter, soon embarked on an adventure that has become a classic of High Sierra folklore. Their five-day trek across absolutely uncharted terrain involved the most difficult and intricate cross-country travel attempted in North America during this era. The present-day backpacker who follows their general route will surely be impressed with the rugged and convoluted country near the serrated divide separating the Kings and Kern rivers. (The former stream, named by the Spaniards, has nothing to do with Clarence King.) Small cliffs continually block progress, and ledges that appear to lead to easier scrambling terminate over hideous dropoffs. Talus slopes are steep and unstable, and treacherous snowfields linger through much of the summer.

Nevertheless, the terrain that makes up the Kings-Kern Divide is by no means as intimidating as King implies in his embellished account recorded nine years later in *Mountaineering in the Sierra Nevada*. Most adventure writers of the late nineteenth century apparently felt their audience would be impressed only with sensational feats, and the journey related by King consequently glows with drama and suspense. In one famous scene, Cotter, in the lead on a steep cliff, drops King a rope and informs him that he can place his weight on it if he so desires. Thus reassured, King decides it would be more sporting to climb the rock itself instead of pulling himself hand over hand up the rope. On reaching Cotter, he is shocked to see his companion perched precariously on a sloping ledge. King realizes that they both could have fallen to their deaths had he actually tugged on the rope. Greatly impressed with his comrade's nobility, King wrote that Cotter "might easily have cast loose that lasso and saved himself." Though it is possible Cotter was indeed a foolish youth who endangered both his and King's life, it seems more likely that King simply exaggerated the incident.

King and Cotter finally managed to reach the top of a high peak, but it was Mount Tyndall, not the higher and more distant Whitney. King's rendition of this ascent makes the reader wonder how both men survived. But they did, returning to the main camp lean and filthy, having completed the first truly ambitious cross-country trip ever recorded in the High Sierra.

The Survey soon moved on to the northern regions of the vast, unexplored range, but King wasn't quite finished with the southern part of the range; he returned a few years later, by himself, to reach Whitney's top at last. But he wasn't the first to gain the highest

summit in the continental United States: A group of local fishermen had preceded him by a month.

After doing a splendid job of directing the Fortieth Parallel Survey in the late 1860s, King founded the United States Geological Survey and headed this prominent organization during its formative years. While in Washington, DC, King, a raconteur blessed with a sparkling personality, became good friends with some of the most noted literary figures of the late century. At King's funeral, in 1901, William Dean Howells and Henry Adams helped bear his casket to the grave. In his most famous work, *The Education of Henry Adams*, Adams said of King: "He knew America, especially west of the hundredth meridian, better than anyone.... He had something in him of the Greek—a touch of Alcibiades or Alexander. One Clarence King only existed in the world."

By the 1870s, though the Sierra Nevada was charted in general outline, most of its interior remained a place of mystery. And although the Survey had been a reputable scientific enterprise, its members had only superficially studied the range's natural history. This was soon to change with the arrival of a young Scot, a man with piercing blue eyes and an unkempt beard.

JOHN MUIR

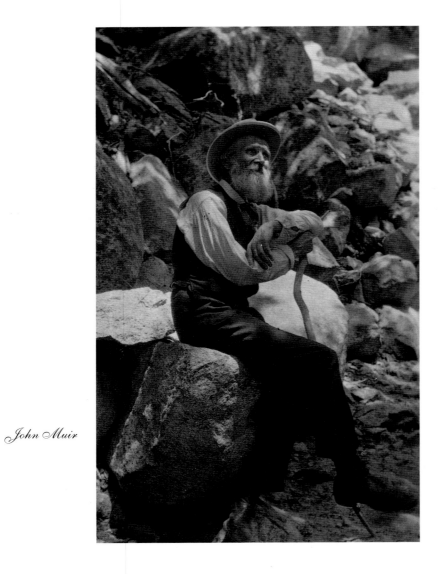

John Muir

\mathcal{T}he reputation of John Muir, by far the best-known Sierra sage, remains untarnished eighty years after his death. Mountaineer, writer, and naturalist, he will be associated forever with the nineteenth-century west. An inquisitive youth, full of wanderlust, Muir first visited the Sierra Nevada in 1868, at age thirty. For a few years he tended sheep, milled fallen logs, scrambled along exposed ledges in Yosemite Valley, and climbed to remote vantage points, always pausing to study the trees, rocks, and canyons. These observations paid off: By the late 1870s he put forth a radical theory about the origin of Yosemite Valley. Professional geologists had long subscribed to the "cataclysm" scenario, wherein the bottom of the gorge had somehow violently dropped thousands of feet, creating a deep chasm. Muir, not so much a heretic as a careful observer, thought otherwise. Burnished granite slabs, with well-defined striations parallel to the main axis of the valley, indicated that glaciers had helped carve the great cleft. Muir, younger and more curious than the aging academics, took to the high country to investigate further. Here he found living glaciers, remnants of the vast ice sheets that once had blanketed the range; this was proof that such large glaciers had once existed. Over the next few decades, Muir's view of how the U-shaped trenches of the High Sierra had been formed became generally accepted—a triumph of personal investigation over textbook speculation.

Muir was a loner, a wanderer who thought nothing of taking a week-long trip to timberline country with only a few hunks of bread and a blanket. He'd curl up among gnarled whitebark pines at dusk, arise at dawn, stretch, and continue on his way, never knowing or caring where

or how he'd end up that night: high or low, catnapping on a bed of pine boughs or shivering on some airy perch. This nontraditional way of moving about in the mountains elicited a wry comment from the eminent naturalist C. Hart Merriam in 1916: "In spite of his having spent a large part of his life in the wilderness, he knew less about camping than almost any man I have ever camped with."

Little is known about the exact course of Muir's wanderings, for though he kept meticulous and eloquent notes of the natural world, he rarely reported his itinerary or his climbs of Sierra peaks. This is unfortunate, for in addition to being a first-rate naturalist and writer, Muir was also a first-class climber. Luckily, he recorded a few of his feats. His 1869 ascent of Cathedral Peak, above Tuolumne Meadows in the Yosemite high country, ranked as the most difficult climb accomplished up to that time in the United States. Alone as usual, he squirmed his way up the final steep spire without a rope, a feat not often imitated today.

Muir's most documented climb is described in his eloquent 1894 book, *The Mountains of California*. In the autumn of 1872 he guided a group of painters, including the soon-to-be-famous William Keith, to Tuolumne Meadows. Leaving his clients to work in this exceedingly lovely place, he set out alone toward the headwaters of the Middle Fork of the San Joaquin River. Unclimbed Mount Ritter was his goal, and he managed to reach its rocky summit successfully, though not without incident. Partway up a steep cliff, Muir found himself clinging tightly to his holds, unable to move in any direction. Just as a fall seemed imminent, "life blazed forth again with preternatural clearness," and he was able to move gingerly upward.

As Muir became older and more famous, his trips to the Sierra tapered off in frequency and intensity—as was true of most of the early explorers. Foreign trips, family obligations, lectures, books—all kept him from his beloved Sierra. Still, men of letters and power sought him out for his views of the natural world: Ralph Waldo Emerson, John Burroughs, and Theodore Roosevelt. The latter wrote Muir before a visit to Yosemite Valley in 1903: "I do not want anyone with me but you, and I want to drop politics absolutely for four days, and just be out in the open with you." The pair had some memorable moments on this trip, including one that should not be emulated today. One night, as they camped alone on the Valley floor, a chilled Muir set fire to a huge, standing dead pine. "Hurrah!" shouted the president. "That's a candle it took five hundred years to make. Hurrah for Yosemite!"

So revered was Muir in California that, upon his death in 1914, the *Sierra Club Bulletin* published an entire issue of poems, memorials, and paeans to him. It was widely believed that he died of a broken heart, for he and the Sierra Club—a conservation organization he had helped form in 1892—had just lost the fight to save Yosemite's Hetch Hetchy Valley from the dam builders. Muir had called this serene granite gorge "one of Nature's rarest and most precious mountain temples." Imagining it filled with water drove him to despair, but he nevertheless had hopes for the future of American wilderness: "The present flourishing triumphant growth of the wealthy wicked . . . will not thrive forever. . . . We may lose this particular fight, but truth and right must prevail at last."

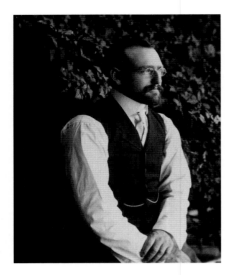

Theodore S. Solomons

THEODORE S. SOLOMONS

The boy of fourteen who gazed at the Sierra Nevada on a pristine spring day in 1884 was unaware of the adventures of Clarence King and John Muir. From his uncle's ranch near Fresno, young Theodore Solomons stared at the distant mountains and for the first time saw them not merely as background objects, but as "the most beautiful and mysterious sight" he had ever beheld. The Holsteins grazing in the vast fields of alfalfa faded from the foreground, and he envisioned himself "in the immensity of that uplifted world, an atom moving along just below the white, crawling from one end to the other of that horizon of high enchantment." This account, written fifty-six years after the event, is surely a romanticized version of a youth's daydream. Still, one would like to believe Solomons's claim that it was on this very day that he first imagined the "idea of a crest-parallel trail through the High Sierra."

During the course of his first major High Sierra trip, to southern Yosemite in 1892, Solomons obtained an enticing glimpse of the South Fork of the San Joaquin, the High Sierra's longest river. Solomons realized that this major watercourse likely sprang from a great cluster of peaks that rose thirty miles to the south. The vision of this unexplored territory haunted him for the two years that passed before he was able to return.

The 1894 expedition undertaken by Solomons and Leigh Bierce was something of a disappointment in that the two men failed in their principal objective: to reach the famed gorge of Kings Canyon, in the far southern Sierra, via a route close to the main crest. "Such a high

mountain route," Solomons wrote in 1895, "practicable for animals, between the two greatest gorges in the Sierra, has never been found— nor, indeed, sought—so far as my researches have revealed." Yet the visionary was confident not only that such a route existed but that it "would be a journey fit for the gods."

In mid-September Solomons and Bierce, along with three pack animals, began ascending the South Fork toward the Sierra crest. Warned by sheepherders of the hazards accompanying autumn storms, the small expedition nevertheless traveled far up the river, eventually curving east up Bear Creek, a major tributary.

On September 20 they reached the base of an isolated peak christened Seven Gables because of its "eccentric shape." That afternoon the pair ascended the 13,075-foot mass and from its top stared in awe at the panorama. A multitude of peaks, mostly unclimbed and unnamed, rose in every quadrant. Immediately to the east lay a cluster of towering summits, below which nestled dozens of jewellike lakes. Spectacular though the landscape was, Solomons knew they had reached an impasse, for their impending route, visible for the first time, looked feasible only to "mythological beasts with wings."

Solomons soon conceived a bold plan: They would leave their pack animals with a sheepherder recently met downstream and set off south with fifty pounds each on their backs. Before this plan could be effected, a major storm intervened, depositing several feet of snow. "We were on top of the Sierra," Solomons wrote, "some seventy-five miles of nearly waist-deep snow between us and the nearest settlements." The exhausted pair retraced their route downstream; finally, on the fifth day, they came upon a stranded herder who plied them with mutton. A few days later they returned to civilization.

Undeterred by this experience, Solomons returned the following year, this time with Ernest Bonner. Solomons was now, more than ever, aware that rugged mountain travel could be accomplished far more effectively without pack animals. With this in mind, he and Bonner worked their way on foot toward the very headwaters of the South Fork of the San Joaquin. The journey of the next two weeks ranks equally in Sierra history with the King-Cotter adventure of 1864. Solomons's accounts of this trip, published in various magazines and journals, are by no means as overblown as King's; indeed, his readable prose is eminently believable, and his enthusiasm for the high country radiates from every page.

On July 19, Solomons and Bonner reached the San Joaquin's source, the goal Solomons had been pursuing for three summers. Here, in an austere world of dead silence, a tiny creek emerged from snowfields below a huge peak. The pair knew they must attempt the dark mass, and the next morning they stood atop 13,568-foot Mount Goddard, obtaining the finest view they had ever seen in the Sierra. Virtually every major peak in the range was etched against the cobalt sky. Four hours passed as the two men absorbed the view, oblivious to an approaching storm. Rain drenched the men as they stumbled down the steep talus. At 11,500 feet they reached the highest pines and stopped for the night. "We had no sooner built a fire," Solomons wrote later, "than the snow began to fall, and though for a time it was nip and tuck between the two elements, our pitch-saturated logs conquered at last."

In the dawn light the two men began traversing east through what is now known as the Ionian Basin. Their immediate goal was a pass Solomons had spied earlier; if they could reach this broad saddle—now called Muir Pass—Solomons felt certain they could then descend into the headwaters region of the Middle Fork of the Kings River. But the storm's intensity increased, thwarting these plans. After struggling across slippery talus for several hours, Solomons resolved to flee the inhospitable alpine world and drop south into a deep gorge he had noticed from Mount Goddard's summit. Passing between two sinister guardian peaks—immediately named Scylla and Charybdis—the adventurers began their descent. Acres of enormous boulders blocked the canyon floor, making their progress painfully tedious. In the rain, the slate forming the canyon walls shone like lustrous metallic plates. This narrow canyon—both menacing and beautiful—was named the Enchanted Gorge.

It was midafternoon on the following day when Solomons and Bonner emerged from the confining canyon into the flat meadowlands bordering the Middle Fork of the Kings River, having made a bone-jarring descent of 7,600 feet in just two days. They had crossed the divide separating the San Joaquin watershed from the Kings drainage by just about the most difficult possible route. (Only three more parties were to pass through the Enchanted Gorge during the next half-century.)

Solomons wrote numerous articles about his adventures, both in the popular press and in the *Sierra Club Bulletin*. But he was not destined to return to the watershed of the Kings River. Shortly after his last Sierra trip, in 1898, he moved to Alaska to become a court reporter. Thirty-five years later, Solomons wrote that he had left California assured about the completion of his high-mountain route: "As for the Kings River section . . . I knew that with LeConte . . . and one or two other indefatigable ones, it was in safe hands."

Joseph N. LeConte indeed became the next stalwart Sierra explorer. His father, a famed geology professor, had introduced him to the range during the 1880s, and by 1892, when LeConte was twenty-two and a new professor of engineering at the University of California at Berkeley, he had begun an illustrious Sierra mountaineering career. In the course of his adventures over the years, LeConte created a set of photographs so excellent that in 1944 Ansel Adams was to praise their quality and aesthetic values: "His photographs are not the fruit of intellectual cogitations; they are the natural, inevitable selections of a man very much in tune with the world about him"

Early on, LeConte became fascinated with the idea of mapping the high country, and to this end he obtained information from Solomons and others, in addition to acquiring firsthand data. In 1893 the Sierra Club published his initial efforts: maps of the Yosemite and Kings Canyon regions. These maps, revised at intervals as new information became available, were greatly appreciated by the members of the newly formed organization, and this reception unquestionably spurred LeConte to broaden his knowledge of the range. For decades he made long pack trips every summer, both for pleasure and to create new maps.

LeConte had for years been fascinated by distant views of the Palisades, a wild and serrated ridge in the central part of the range. By 1903 the rugged uplift was just about the last major uncharted region of the High Sierra, and he decided to investigate. His July trip was a classic of rugged mountain exploration. LeConte, his wife Helen, James Hutchinson, James Moffitt, John Pike, and Robert Pike hiked to Marion Lake, deep inside the range; then, leaving Helen LeConte and John Pike to tend camp, the four others struck north. Up and down

they went, skirting peaks and dropping down endless gorges. Finally, they reached an idyllic glade on Palisade Creek. This place, according to LeConte, was "absolutely untouched. Not since the creation of the forest reserve [in 1893] had human foot trod this glorious wilderness, and even before that time the sheepmen who visited the valley must have been few indeed, for not a blaze, monument, nor corral did we see, and there were but few signs of old sheep-camps."

That night's camp was established at timberline, not far below the mysterious peaks. At dawn the men left camp and worked their way up Glacier Creek, traversing meadows, talus, and finally snowfields that reached for the sky. Here they encountered acres of sun cups, a phenomenon familiar to all who venture into the subalpine world. "The unequal melting of the snow," wrote LeConte later, "cut the whole mass up into a labyrinth of great knife-blades, which were sometimes four feet high and two or three feet apart. We were forced to step from blade to blade, balancing on the sharp edges, and often falling into the spaces between."

In spite of such obstacles, the well-conditioned men soon reached the main Sierra crest, astonished to see, just below, what they knew must be the largest glacier in the range, complete with crevasses and glistening ice. Greatly impressed with this unexpected sight, they turned toward the highest peak—North Palisade—and groaned. The jagged half-mile ridge leading over to its summit appeared impassible. Hutchinson carefully traversed to the brink of a huge gash—now called the U-Notch—and verified the prognosis. The disappointed men scrambled up a consolation prize to the east: Mount Sill, a massive peak that LeConte had seen and named seven years earlier. But there was no question in anyone's mind that the grand view was flawed in one

respect: the presence of nearby North Palisade, eighty feet higher and still unclimbed.

The next morning LeConte, Hutchinson, and Moffitt set off from camp once again. Soon they stood below North Palisade's 1,500-foot-high southwest face, an imposing escarpment riven only by a few steep chutes. Choosing the most prominent of these, the three climbers worked up it until stymied by steepening cliffs. Since these appeared unclimbable, it seemed the group must fail once again. But as LeConte peered down the chute they had just ascended, he spied a narrow ledge snaking around a corner. This proved to be the key to the ascent, for the sloping shelf led to an easier chute, which eventually ended near the summit. The highest of the Palisades had been vanquished, and the geography of yet another remote part of the High Sierra was better understood.

LeConte later made dozens of trips into the range, including, in 1908, the first continuous trek down the length of the innermost High Sierra. Later, much of his route became the famed John Muir Trail, begun in 1915 and finished in 1938. Solomons's vision of 1884 had finally been fulfilled.

In 1930, LeConte's health began failing. "My doctor and my common sense," he wrote in his diary of that year, "told me that there were no more High Sierra packing trips for me . . . but nothing can ever efface the memory of those forty-four glorious Sierra trips. Those are something that can never be equaled." He died in 1950.

MEMBERS OF THE 1903 EXPEDITION TO NORTH PALISADE
John Pike, Edward Hutchinson, Joseph N. LeConte, and James Hutchinson

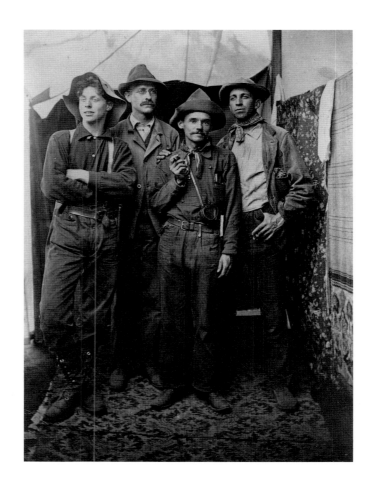

15

During the nineteenth-century exploration of the Sierra Nevada, women were virtually nonexistent; it was a man's world. But in 1903 a remarkable woman named Marion Randall began to change that. A San Francisco native, the twenty-five-year-old Randall joined a Sierra Club trip to the Yosemite region, an event that—almost literally overnight—changed her life. She not only became entranced with the Range of Light, as Muir had called the Sierra, but she met her future husband, Edward Parsons, a director of the Sierra Club and a business-man seventeen years her senior. Marion Randall Parsons soon became a lifelong champion of the Sierra Club, participating in dozens of the outings the club began in 1901 (and abandoned in the 1960s as being too destructive of the fragile landscape).

The Sierra Club outings accommodated up to two hundred people at a time. For several weeks the horde of city dwellers moved through a section of the range, camping for several days in some idyllic glade, then moving on to a new locale. Strings of pack animals transported the paraphernalia necessary for the self-contained expedition. Huge iron stoves, cooking pots, bedding, and vast amounts of foodstuffs had to be balanced carefully on the mules' backs. Packers, cooks, and their assistants broke camp as soon as possible after breakfast and traveled at a steady rate in order to have the next camp established by the time the outing participants arrived singly or in small groups.

Women were discouraged from participating in strenuous optional activities on these outings, for many men thought they couldn't with-stand the rigorous outdoor life. But Parsons soon proved otherwise. On the 1907 outing, for instance, a small group of adventurers, including Parsons, left the main encampment in southern Yosemite and tramped for days across rugged, unknown country toward Mount Ritter. Parsons

especially craved this prominent summit, for she well remembered an event that had taken place three years earlier when, as she wrote, her "feminine aspirations toward that very mountain were crushed by the stern masculine decree that fair ladies' backs were not fitted to bear such burdens. . . . " Needless to say, Parsons had no trouble with the ascent; indeed, she reveled in the "mysterious atmosphere" of the heights.

Parsons joined many such demanding excursions, leading the way for a more open attitude toward what was obviously not the "weaker sex." She was often called upon to write the official account of the summer's journey for that year's *Sierra Club Bulletin*. Sixteen of her eloquent articles appeared over a forty-seven-year span, easily a record for that prestigious journal. Rather than merely outline the itinerary of a trip, she wrote with warmth and wit about the joys and travails of the outing participants. Her descriptions of people interacting with the land-scape are still a delight to read; several excerpts are found in this book.

Far from being only a Sierra walker, Parsons took part in club outings to the Pacific Northwest and Canada, chronicling these major journeys with the same spirit as she did those on her home turf. Her husband died in 1914, but this slowed her only for a year; she was hardly the type to retreat into quiet widowhood. She sailed to France in 1918 with the Red Cross to help with the war effort; later she became an accomplished painter, pianist, and novelist. When Parsons died in 1953, at age seventy-five, her friend Benjamin Lehman closed her obit-uary in the *Sierra Club Bulletin* with these words: "She was one of the not very conspicuous people who quietly operate to make civilization."

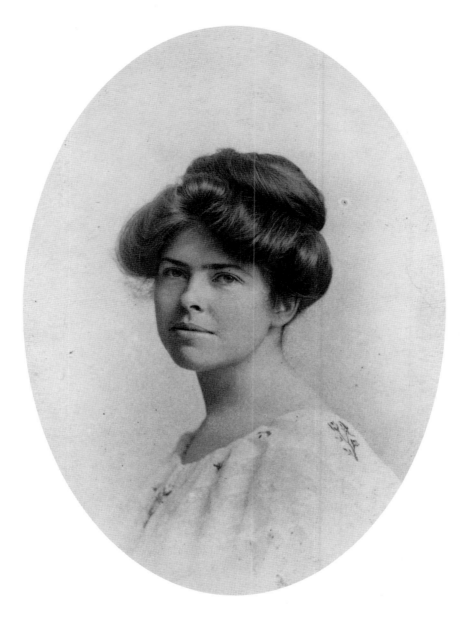

Marion Randall Parsons

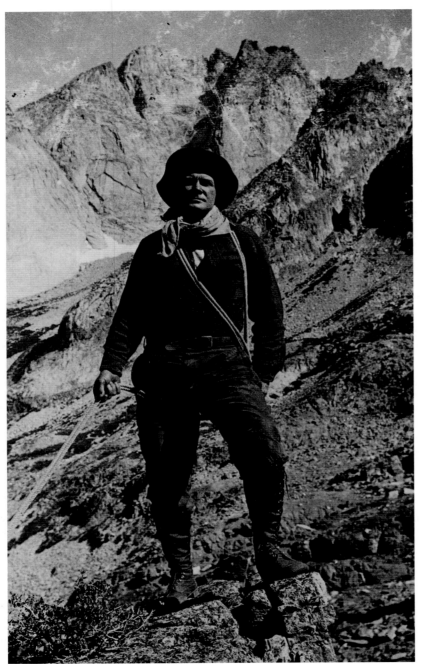

Norman Clyde, 1930

NORMAN CLYDE

By the end of the 1930s, nearly every remote cirque and peak of the High Sierra had been explored, for during the period between the two world wars the last bastions of the unknown—the summits theselves—were conquered. Numerous climbers of this period sought out the fine, untouched peaks that had been ignored by the turn-of-the-century pioneers, but no one individual left his footprints on so many of them as Norman Clyde. This scholar of the classics began his Sierra climbing rampage in 1914, following the death of his young wife. A half-century later he was the veteran of perhaps a thousand ascents, of which 125 were either first ascents or new routes up previously ascended mountains. In a letter to an acquaintance in 1925, he wrote: "I sometimes think I climbed enough peaks this summer to render me a candidate for a padded cell—at least some people look at the matter in that way." If, as a mountain pundit once said, the mark of a true mountaineer is his willingness to repeat climbs, then Clyde qualifies as few others are ever likely to do. He had numerous "most favorite" peaks and would climb them year after year: he ascended lofty Mount Thompson about fifty times.

During the 1920s and 1930s, the period of his most prolific climbing, Clyde served as a guide on the annual outings of the Sierra Club,

thus becoming a well-known figure to many high-country travelers. An unhurried eccentric, Clyde transported a ninety-pound pack from one campsite to another, and watching him set up camp was always a thrill. Out of the bottomless pack would appear a pistol, an axe, a cast-iron frying pan, several heavy pots, three fishing rods, archaic camping gear— and the *Odyssey* in its original Greek! One wonders what John Muir, with his fifteen-pound pack, would have thought of this mound of gear.

This quiet, cranky, slow-moving man was also a mountain detective; several times he unerringly led searchers to the corpses of those who had come to grief on the crags. One day might find him sitting motionless against a lodgepole pine absorbed in Homer; the next might find him alone, atop some obscure peak, scanning the heights with binoculars for a missing man, trying to intuit where the unfortunate one had strayed.

Clyde cared little about money or up-to-date gear; he lived simply and without pretension. His last job that could be called "normal" ended in a mini-scandal in 1927, when he was but forty-two. While acting as a high school principal in the village of Independence, on the Sierra's east flank, he was harassed by rowdy youths on Halloween night. Fetching his rifle, he fired several shots over their heads to teach them a lesson—and was quickly dismissed for this frontier behavior. He told authorities that if he'd wanted to hit them he could have; the fact that he missed was proof he wasn't seriously trying to hurt them. This logic failed to sway his superiors.

Clyde then worked as the winter caretaker of a mountain lodge for many years, as well as continuing to serve as a woodcutter and general handyman on Sierra Club outings. He retired from this position in 1970, at age eighty-five, and died two years later in Big Pine, on his beloved east side of the Sierra.

Compared to the other five pioneers described here, Clyde wrote relatively little of merit. His articles, devoid of personal touches and almost unendurably dull, rarely mention his companions or his inner thoughts. Clyde, a brooding loner, had few friends and little contact with the outside world. In this regard he stood out dramatically from the other five, all of whom were notable for their worldly, effusive personalities. What he did share in common with all these other explorers, though, was a love of the Range of Light, that austere universe illuminated by these photographs.

This book is dedicated
to my favorite backcountry companion,
Nancy Ingersoll Fiddler.

Canyon

(PACK)

8896 T

TRAIL

SCENIC

7962 T

9164 T

Stubblefield

9047 T

Y O S E M I T E

CREST

PACIFIC CREST

8047 T

1-237

Creek Canyon

9284 T

Kerrick

9154 T

Creek

-BO
146

Rancheria

VFGI-G
3-58

99077

Canyon

10200

9200

W I L D E R N E S S

Kerrick

SCENIC TRAIL (PACK)

94897

3-12

Seavey
Pass

9200

9400

3-57

PACIFIC

10541T Piute
 Mountain

9470T

CREST

NATIONAL

After discussing these high questions with Mr. Muir for some time, we
walked to the edge of the Yosemite chasm, and out on the projecting
point of Three Brothers, called Eagle Point. Here we had our last, and
certainly one of the most magnificent views of the valley and the High
Sierra. I can only name the points which are in view, and leave the
reader to fill out the picture. As we look up the valley, to the near left
is Yosemite Falls, but not a very good view; then Washington Column,
North Dome; then grand old South Dome. The view of this grand
feature of Yosemite is here magnificent. It is seen in half profile. Its
rounded head, its perpendicular rock face, its towering height, and its
massive proportions are well seen.

J O S E P H N. L E C O N T E , *1875*

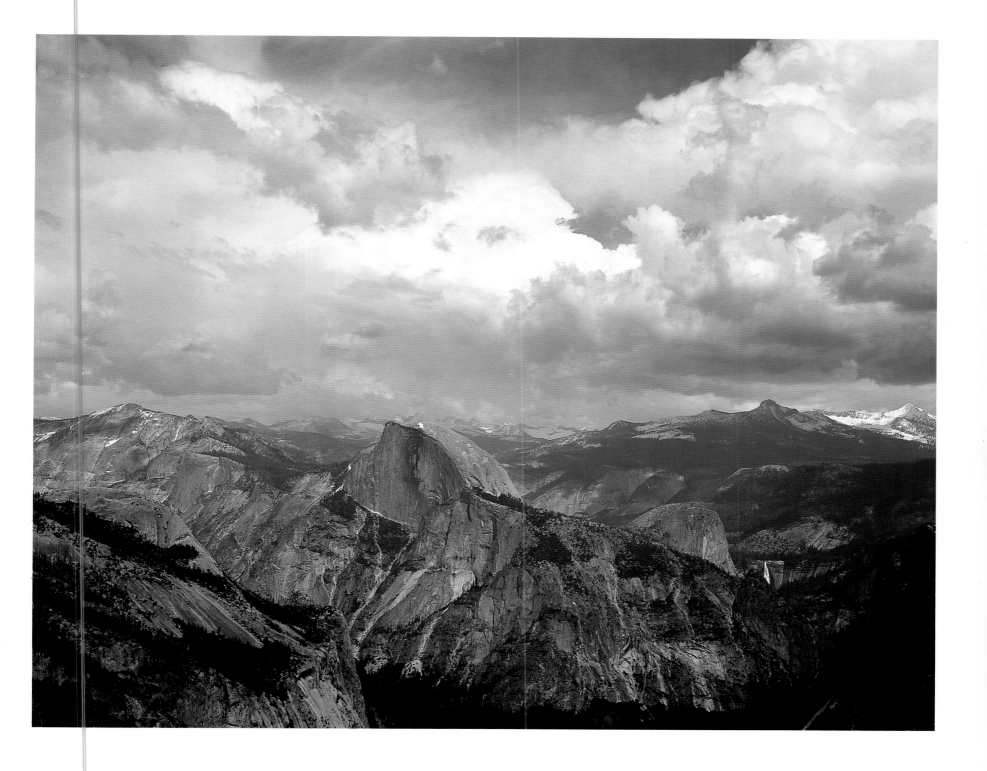

What store of happy memories we carry back with us each year! What pictures that refresh
the inward eye when wearied with its daily rounds! What greater gift has California for
her children than the glorious Sierra, whose melting snows not only water the thirsty plains
below, but in whose fastnesses we find a free renewal of life, youth, and joyous freedom!

HELEN LECONTE, *1903*

YOSEMITE NATIONAL PARK Tuolumne Meadows and northern Yosemite from Fairview Dome

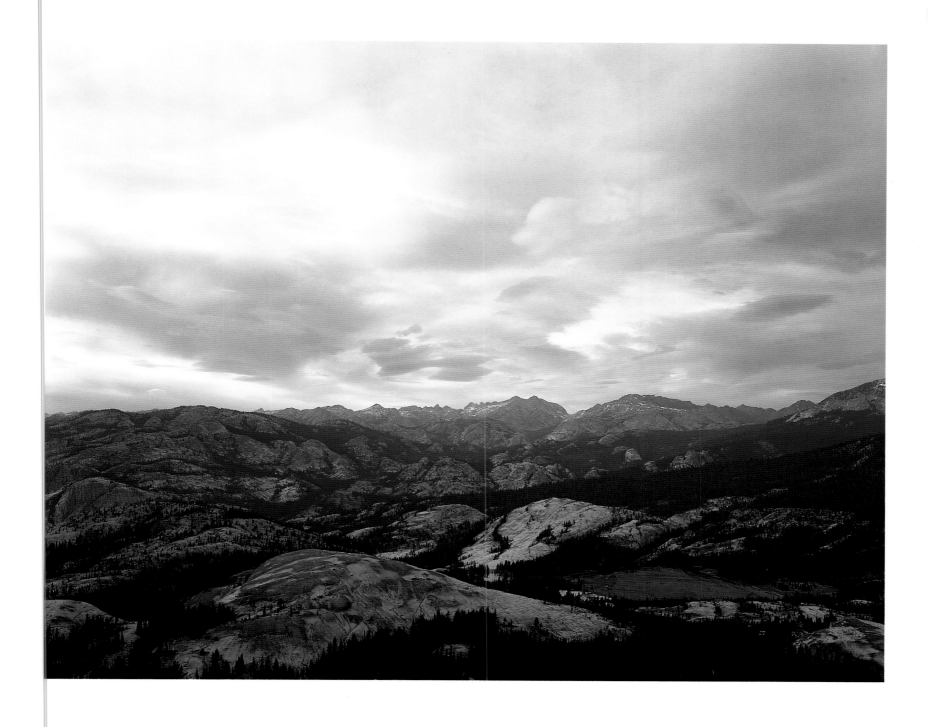

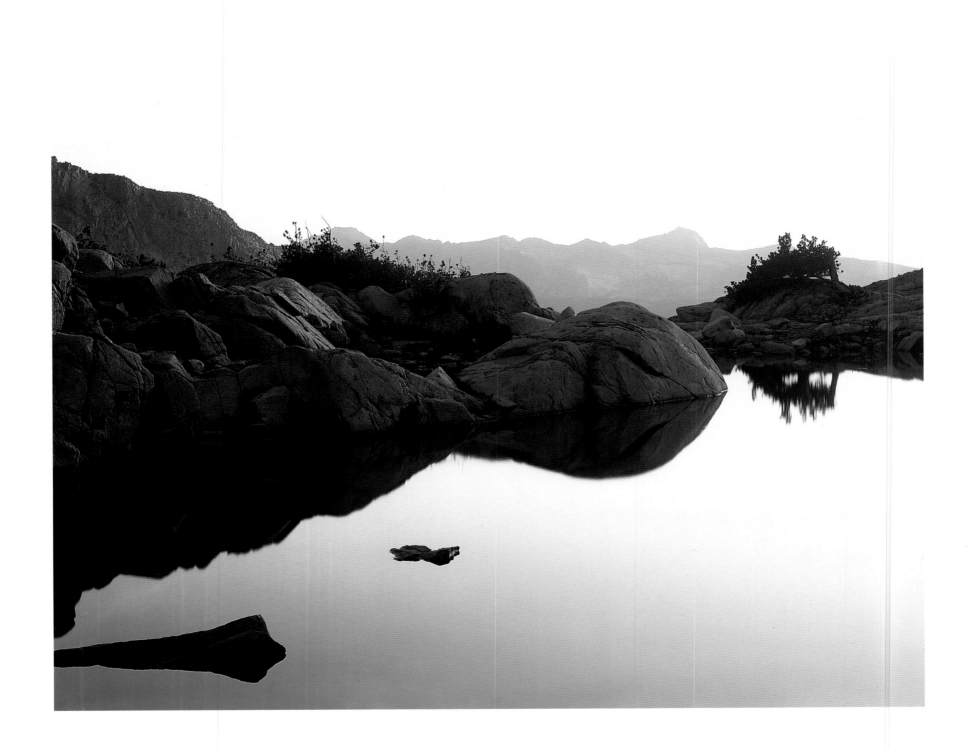

The whole aspect of the region is peculiar; the impression
is one of grandeur, but at the same time of desolation—the
dark pines, the light granite, the sharp cones behind, the
absence of all sounds except the sighing of the wind through
the pines or the rippling of streams. There is an occasional
bird heard, but for most of the time silence reigns. At night
the wind dies down, the clouds disappear, if any have
occurred during the day, and everything is still. During the
night there is no sound. The sky is very clear and almost
black; the stars scarcely twinkle, but shine with a calm,
steady, silvery light from this black dome above.

WILLIAM H. BREWER, *1864*

The Clark Range from the Lyell Fork of the Merced River YOSEMITE NATIONAL PARK

I drifted about from rock to rock, from stream to stream, from grove to grove. Where night found me, there I camped. When I discovered a new plant, I sat down beside it for a minute or a day, to make its acquaintance and hear what it had to tell. When I came to moraines, or ice-scratches upon the rocks, I traced them back, learning what I could of the glacier that made them. I asked the bowlders I met, whence they came and whither they are going. I followed to their fountains the traces of the various soils upon which the forests and meadows are planted; and when I discovered a mountain or rock of marked form and structure, I climbed about it, comparing it with its neighbors, marking its relations to living or dead glaciers, streams of water, avalanches of snow, etc., in seeking to account for its existence and character.

JOHN MUIR, *1873*

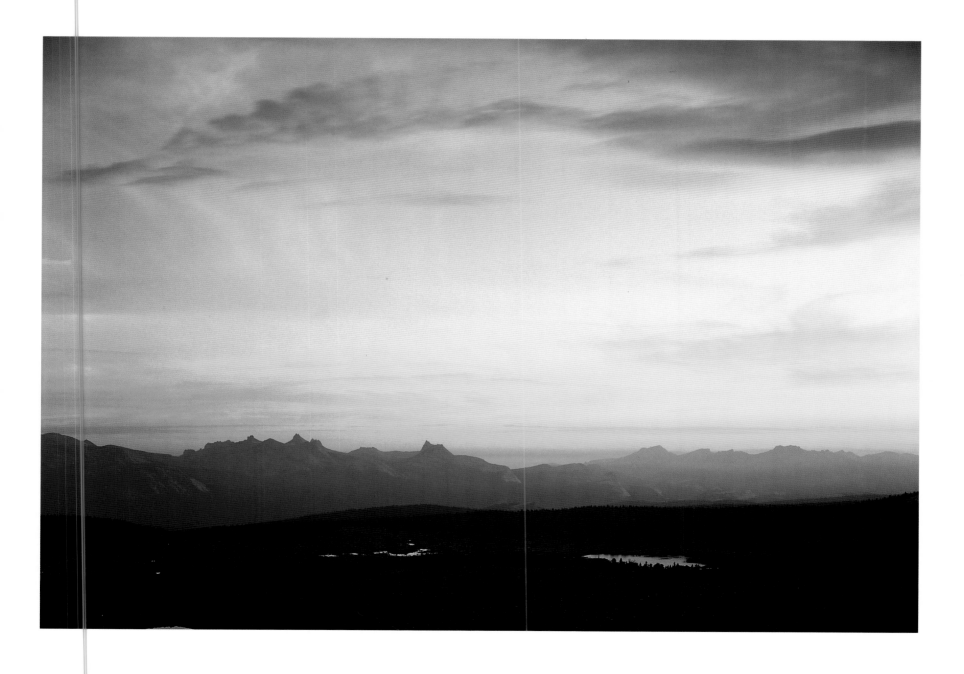

I never weary gazing at the wonderful Cathedral. It has more individual character than any other rock or mountain I ever saw, excepting perhaps the Yosemite South Dome. The forests, too, seem kindly familiar, and the lakes and meadows and glad singing streams. I should like to dwell with them forever. Here with bread and water I should be content. Even if not allowed to roam and climb, tethered to a stake or tree in some meadow or grove, I should be content forever. Bathed in such beauty, watching the expressions ever varying on the faces of the mountains, watching the stars, which here have a glory that the lowlander never dreams of, watching the circling seasons, listening to the songs of the waters and winds and birds, would be endless pleasure.

JOHN MUIR, *1911*

YOSEMITE NATIONAL PARK Cathedral Peak from Columbia Finger

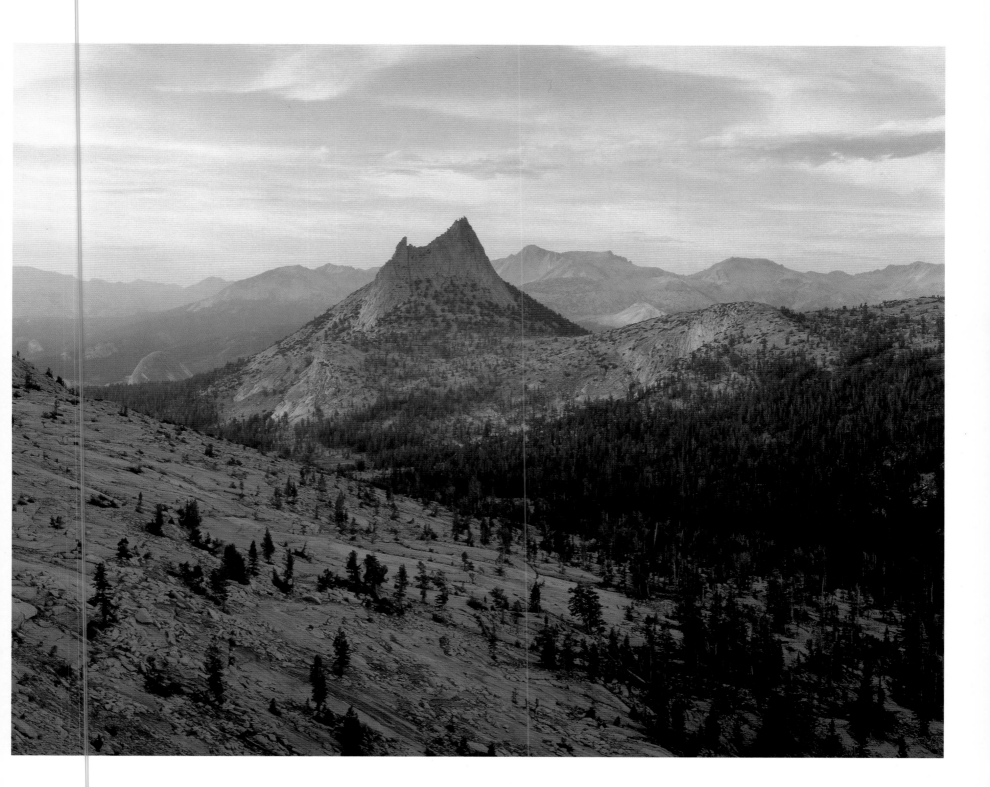

The battle we have fought, and are still fighting, for the forests
is a part of the eternal conflict between right and wrong, and
we cannot expect to see the end of it. . . . I doubt not, if only
one of our grand trees on the Sierra were reserved as an
example and type of all that is most noble and glorious in
mountain trees, it would not be long before you would find a
lumberman and a lawyer at the foot of it, eagerly proving by
every law terrestrial and celestial that that tree must come
down. So we must count on watching and striving for these
trees, and should always be glad to find anything so surely
good and noble to strive for.

JOSEPH N. LECONTE, *1895*

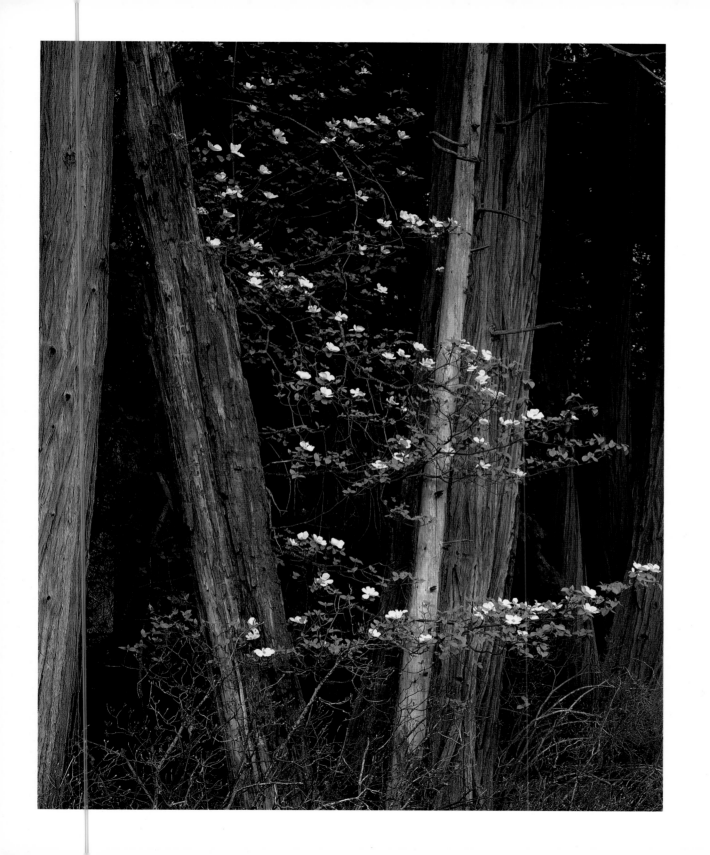

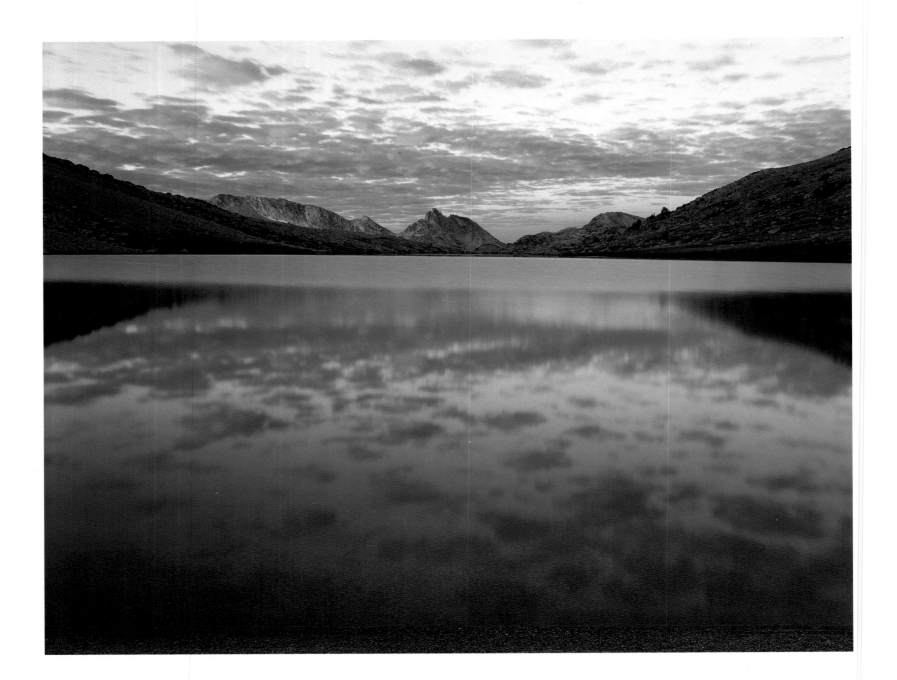

A mysterious atmosphere, not quite of the everyday world, surrounds the loftiest mountain tops. The high, clear air that blows across them is as a breath from the inner sanctuary, the holy of holies, of the great temple of out-of-doors. It is peaceful, restful, serene; and yet every crest and pinnacle within the broad horizon thrills one with a call to further effort, with a vague unrest like the rainbow lure or the voice of the sea.

MARION RANDALL PARSONS, *1908*

The glacier of Mount Lyell floats as a pale ship upon a sea of desolate granite; the Sierra crest is drawn back and unresponsive in the distance. It is a rather futile view—the great peaks are too remote for intimacy and too near for imaginative splendor. But the warm sun and diamond air, and the friendly, fantastic trees alleviate the severity of isolation.

ANSEL ADAMS, *1932*

YOSEMITE NATIONAL PARK Mount Lyell and Mount Maclure from Kuna Crest

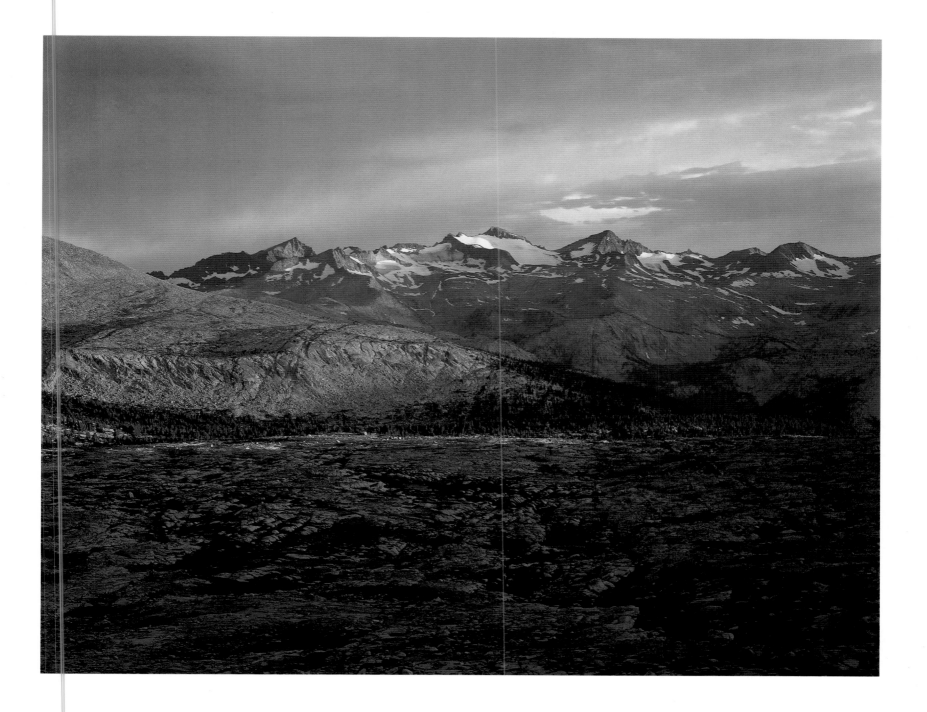

The sky was overcast when we started and we had not been long on the trail before the rain overtook us, light, grateful showers that hung sparkling drops in the firs and washed the dust of the trail from the delicate pink pentstemon and purple daisies that brushed against us as we passed. Now the clouds would part, showing a distant snow-capped peak or a patch of brilliant sky; or again a downpour of heavy drops would drive us to the shelter of a friendly yellow pine or a canopy of tamaracks.

MARION RANDALL PARSONS, *1909*

YOSEMITE NATIONAL PARK Storm over the Cathedral Range from Kuna Crest

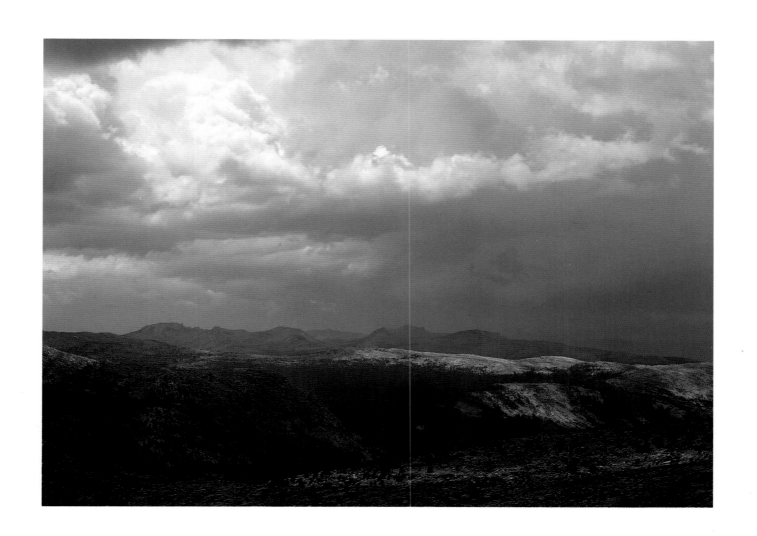

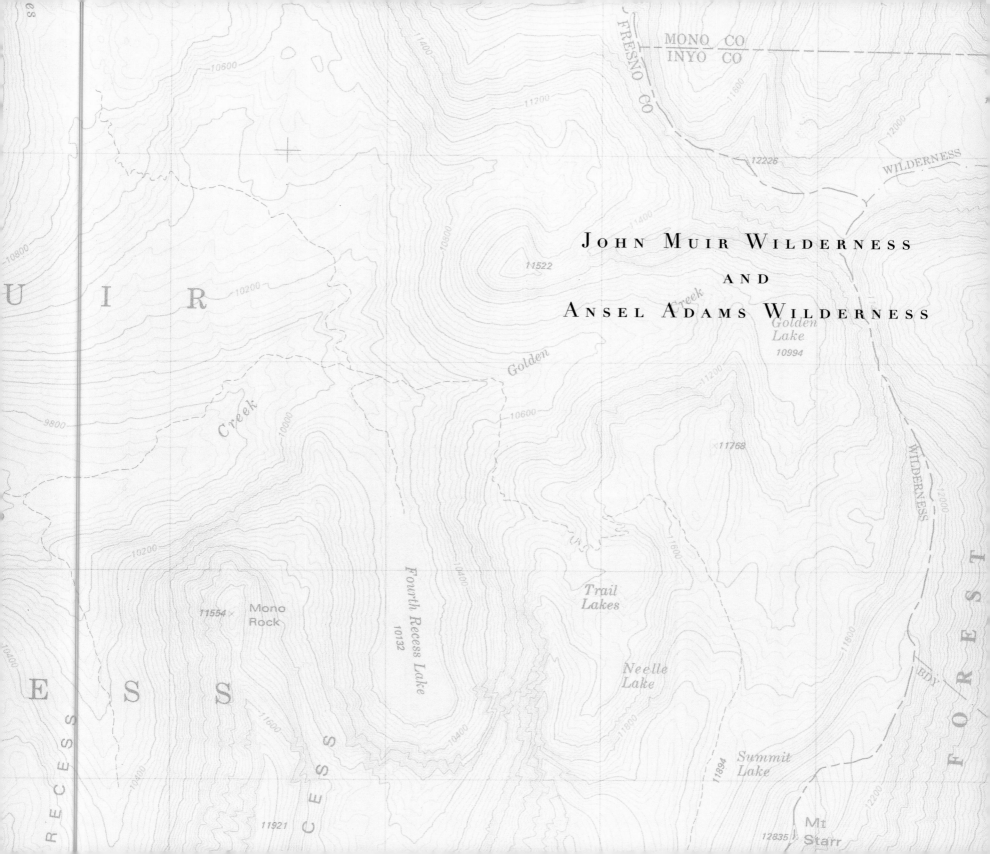

JOHN MUIR WILDERNESS

AND

ANSEL ADAMS WILDERNESS

All the early morning the sky was thronged with cloud and
a sharp wind beat upon the crags. Before noon an eager
arm of cloud clutched at the sun, and a sigh of shadow came
over the mountains. Rippling patterns of wind flashed on
turquoise waters—ice-fields became cold gray as the moon
before dawn. It was good to feel the tiny flagellations of the
rain—it was good to be buffeted by cool and fragrant air.
And one must ever bow before the deep benediction of thun-
der. We sat for long under a rocky shelter while the storm
moved over the pass and roared down-cañon to westward.
High summits were veiled in massive clouds that swirled
and blended above us.

ANSEL ADAMS, 1932

44

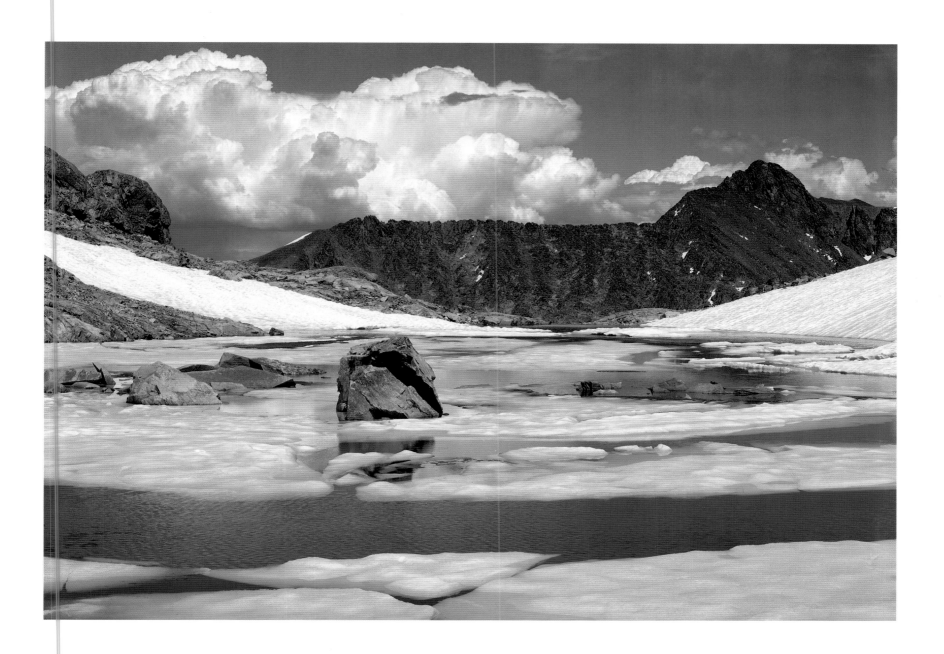

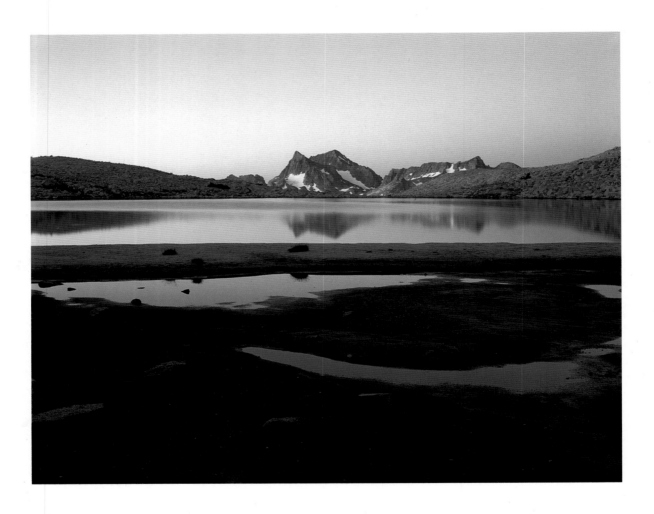

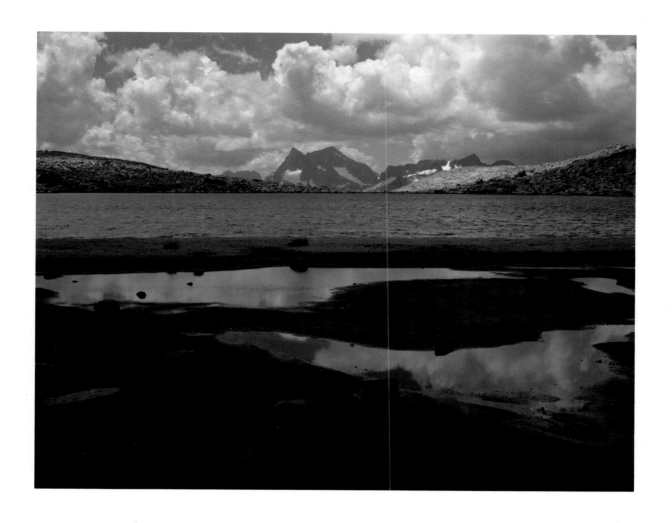

The views of Mount Ritter here were magnificent. I doubt if in the whole Sierra there is a more
noble mountain than this, standing so high and clear-cut above everything around it, and so
brilliantly contrasting black rock and snow. Wherever it is visible, Ritter fascinates the beholder.

JOSEPH N. LECONTE, *1909*

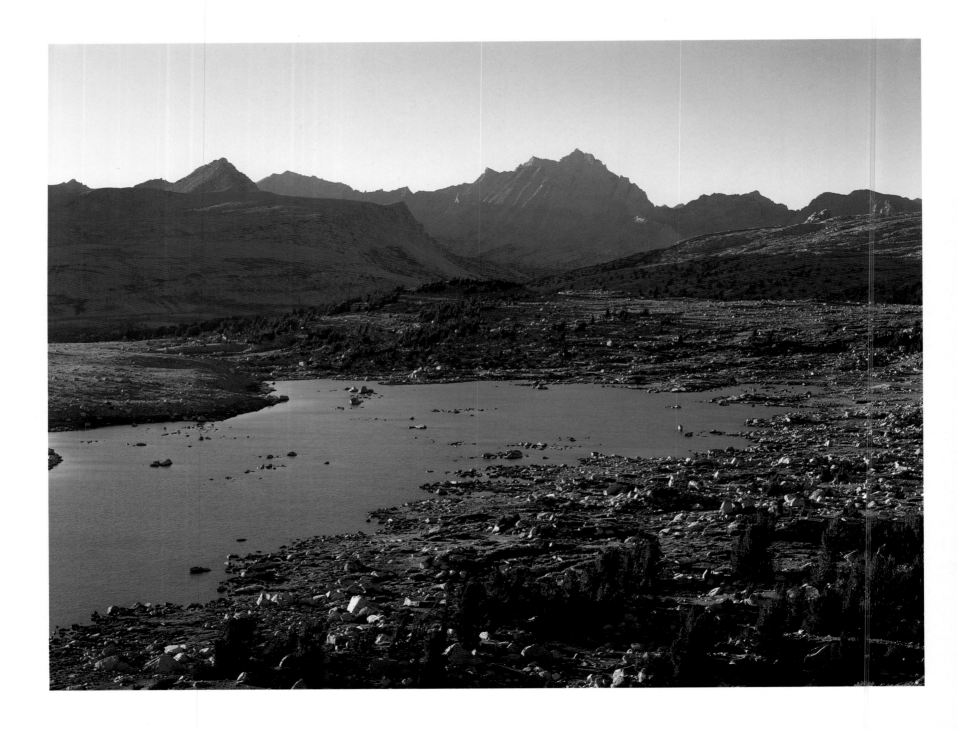

How pleasingly this basin contrasts with the severity of the Kings-Kern
Divide—its long inclines, its broad hollows filled with lakes and meadows,
its somber distant aspect of ridges and forest, all blending in soothing
tranquility with the late afternoon diffusion of sunlight! We marched into
the evening, past the beaten remains of trees that spoke of a once kindlier
climate, into a last stand of lodgepoles. . . . Sonorously, a Hermit Thrush
gave cheer to the efforts of this forest to survive. . . . Intangible in shadow
the peaks appeared closer, as if they, too, were listening to the ethereal
Sierran fugue.

DAVID BROWER, *1935*

Bear Creek Spire from "L" Lake JOHN MUIR WILDERNESS

Here in California you have some of the great wonders of the world. You have a singularly beautiful landscape, singularly beautiful and singularly majestic scenery, and it should certainly be your aim to try to preserve for those who are to come after you that beauty; to try to keep unmarred that majesty. . . . There is nothing more practical in the end than the preservation of beauty, than the preservation of anything that appeals to the higher emotions of mankind.

THEODORE ROOSEVELT, *1903*

JOHN MUIR WILDERNESS Mount Irvine reflected in Meysan Lake

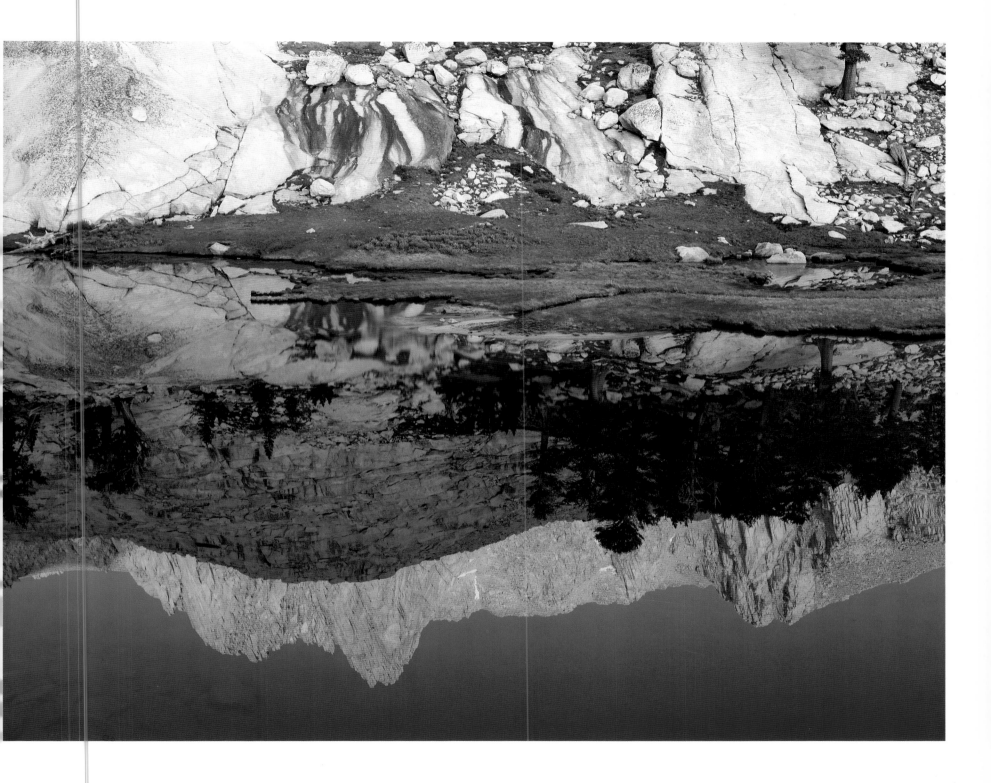

How softly these mountain rocks are adorned, and how fine and reassuring the company they keep—their brows in the sky, their feet set in groves and gay emerald meadows, a thousand flowers leaning confidently against their adamantine bosses, while birds, bees, and butterflies help the river and waterfalls to stir all the air into music—things frail and fleeting and types of permanence meeting here and blending, as if into this glorious mountain temple Nature had gathered her choicest treasures, whether great or small, to draw her lovers into close confiding communion with her.

JOHN MUIR, *1908*

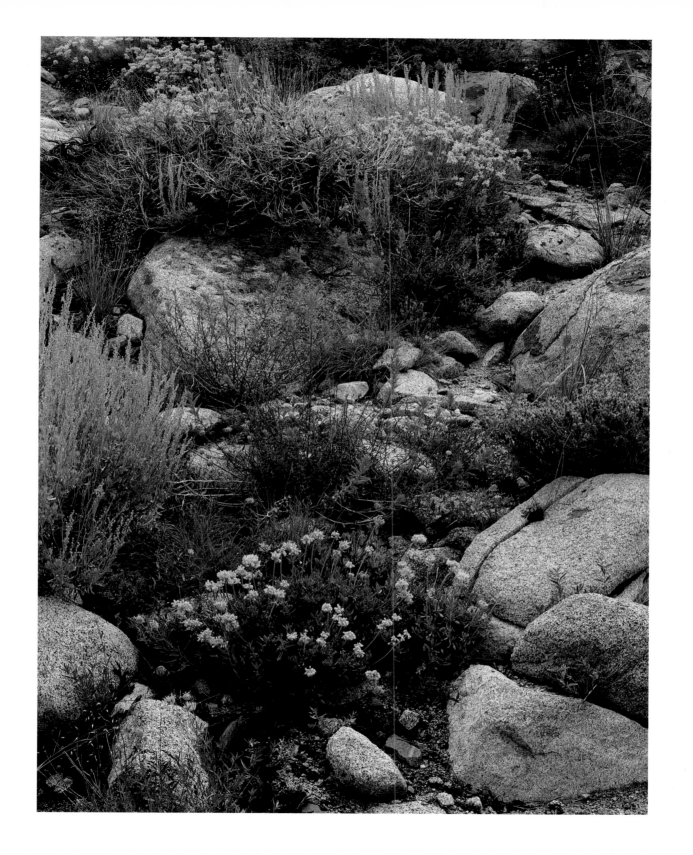

Write as I may, I cannot give anything like an adequate idea
of the exquisite beauty of these mountain carpets as they lie
smoothly outspread in the savage wilderness. What words
are fine enough to picture them? To what shall we liken
them? The flowery levels of the prairies of the old West, the
luxuriant savannahs of the South, and the finest cultivated
meadows are coarse in comparison.

JOHN MUIR, 1894

ANSEL ADAMS WILDERNESS Sierra primroses near Mount Ritter

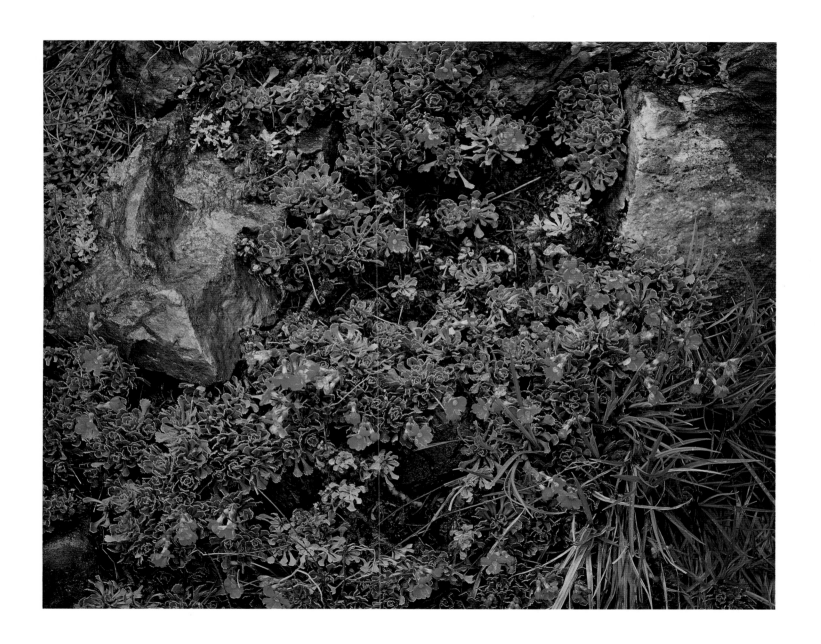

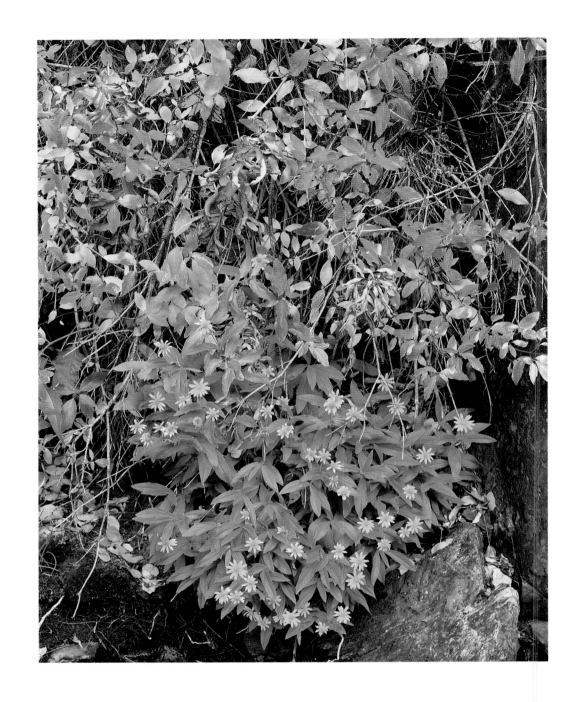

When the mountains evoke a melody, a song, a thought, sing it
with you—it is that spirit back of mountain and song which is
the precious new world we need to find. It is in wave-lines of
checkered sunlight and shimmer of wind flicking across some
high green snow-lake. Or, appearing suddenly, while watching
mountains, a cold effervescence in the heart, a touch of . . . what
else than a glimpse of cosmic reality. . . . That tingling spirit
haunts all the high country like a majestic hymn, for those who
see and feel beneath the surface of things.

CEDRIC WRIGHT, *1928*

Our gorges are deeper than those of the Alps, our valleys
more beautiful, our peaks as lofty and precipitous, and every
danger that the most reckless pervert could sigh for, save
those of the ice, may be encountered without much search.
On the other hand, the absence of large bodies of ice and
snow makes exploration so easy and safe as to practically
insure to the moderately cautious all the pleasures and bene-
fits of true Alpine life, with none of its serious disadvantages.

THEODORE S. SOLOMONS, *1896*

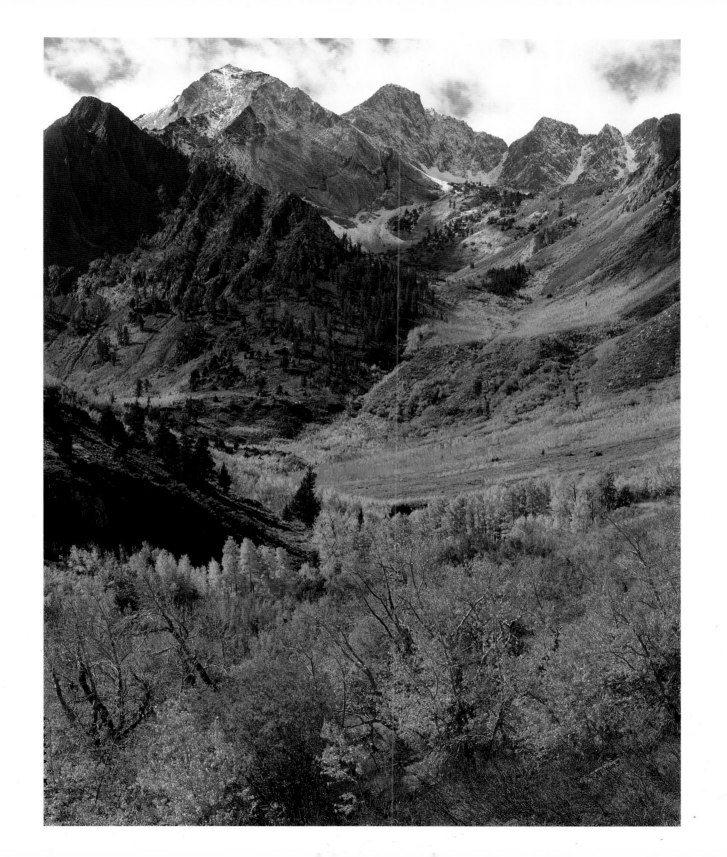

For the mountaineer the major attraction of the region is
Mount Humphreys. To those fond of rock-climbing it will
always be one of the most alluring of the high peaks of the
Sierra. Its peculiarly forbidding, almost sinister aspect, as
it towers in solitary grandeur above the desolate basin at
its base, seems to hurl a challenge to the adventurous
mountaineer. There is also a fascination in the very basin
itself, with its wide outlook and its rolling treeless expanse
of bare glaciated rock and grassy meadow. . . .

NORMAN CLYDE, *1928*

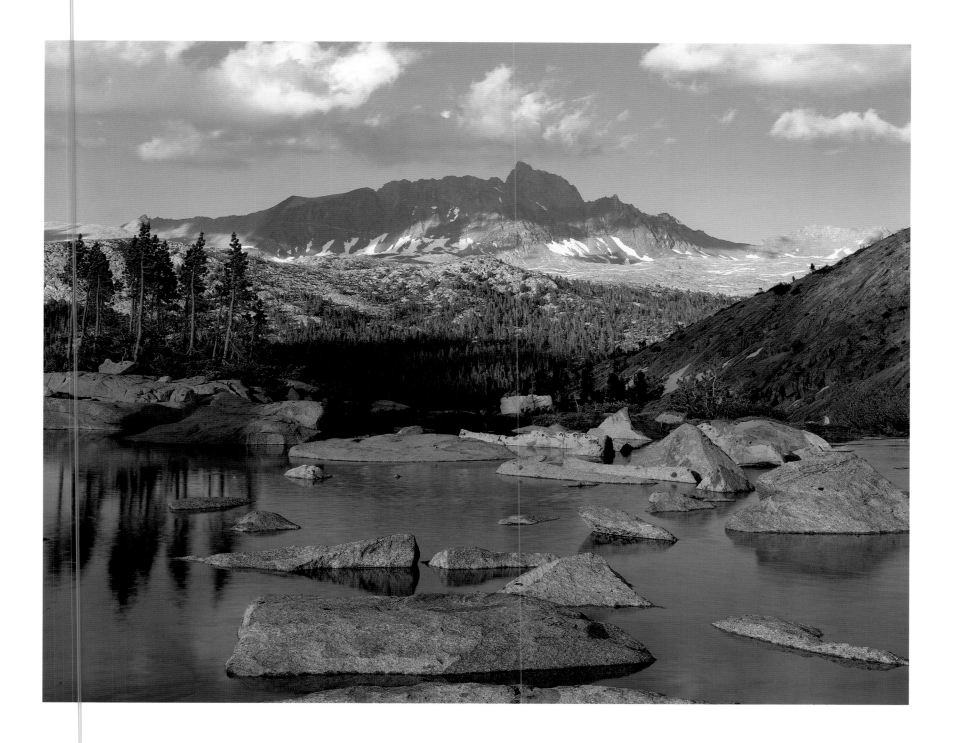

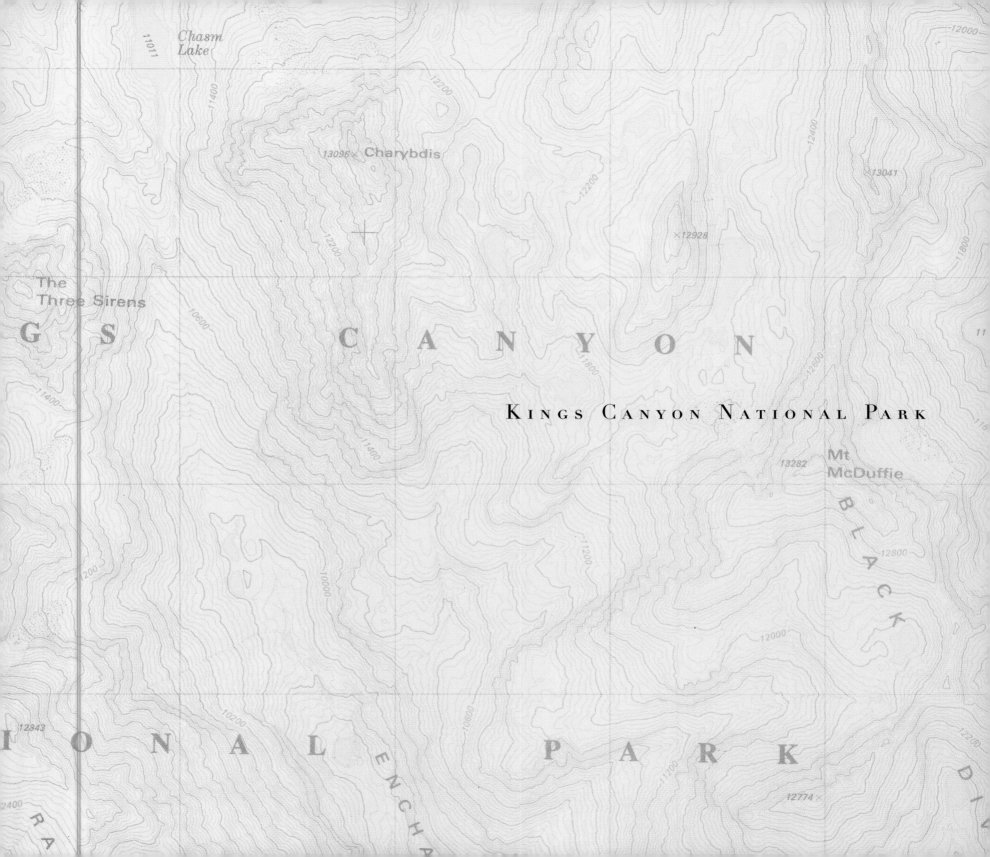

64

Such trees, such rocks, such flowers, such vasty gulfs of air above, below, and
around; such wealth of warm sunshine; such a paradise of sunny solitude sweep-
ing aloft far into the sky's deepest blue—these and the intoxication of the air at
ten thousand feet, the sublime beauty of the ranges of snowy peaks, the silver
thread of the river winding through the blue haze thousands of feet below—these,
and many other sweet influences, stirred in me a deeper sense of the *heavenliness*
of the mountains and a deeper joy in them than was ever mine before.

BOLTON COIT BROWN, *1896*

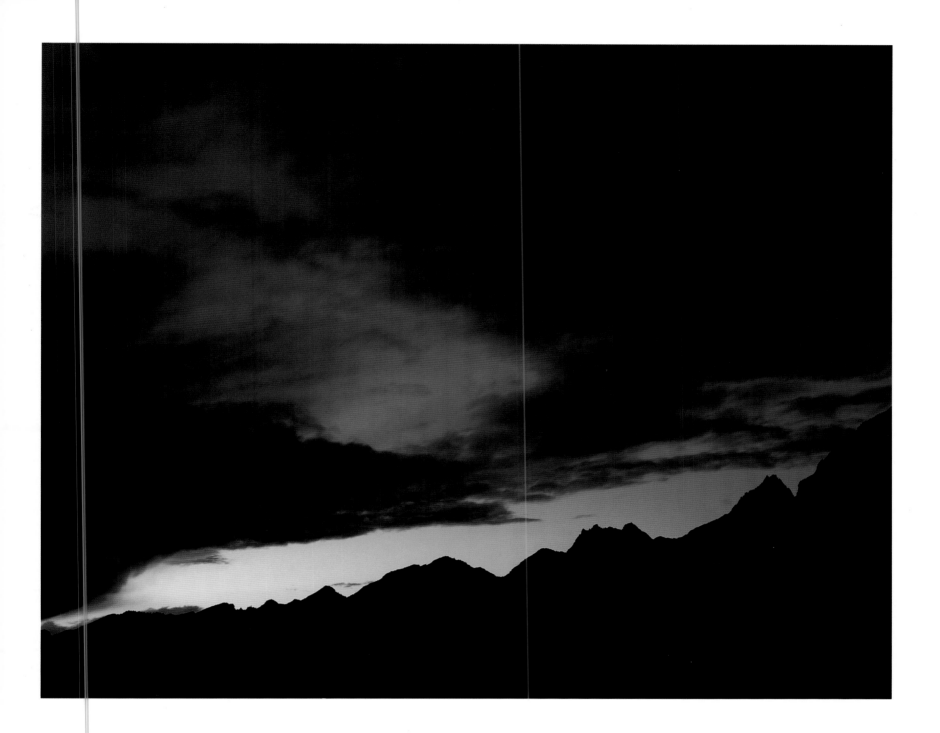

The Palisade country, I have reason to believe, is the acme of alpine sublimity

on the American continent. . . . Certainly it is the most formidable of conquest of

any part of the California Alps. There is here a very chaos of gorges of appalling

depth and savage aspect, separating and throwing into fearful relief a great mass

of peaks, precipices, and cliffs, amongst which glitter frozen lakes, cascades, snow-

fields, and, it is said, glaciers. Over this Titan's pandemonium tower the Palisades

or Sawteeth, flinging aloft their pinnacled crests a thousand feet clear of the

surrounding mountains.

THEODORE S. SOLOMONS, *1896*

KINGS CANYON NATIONAL PARK North Palisade from Rambaud Creek, Black Divide

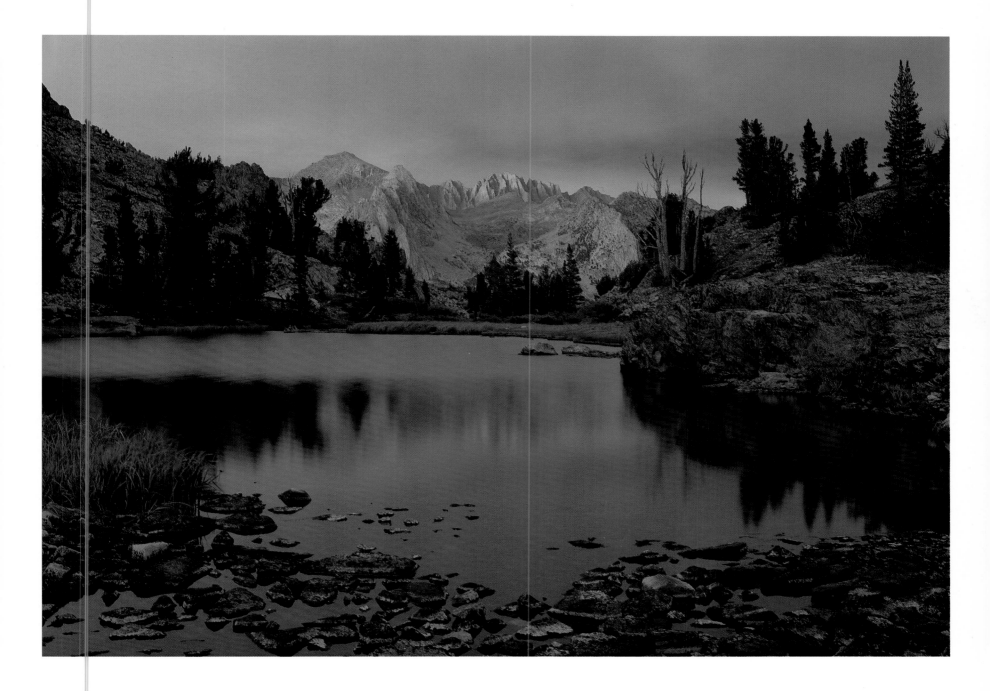

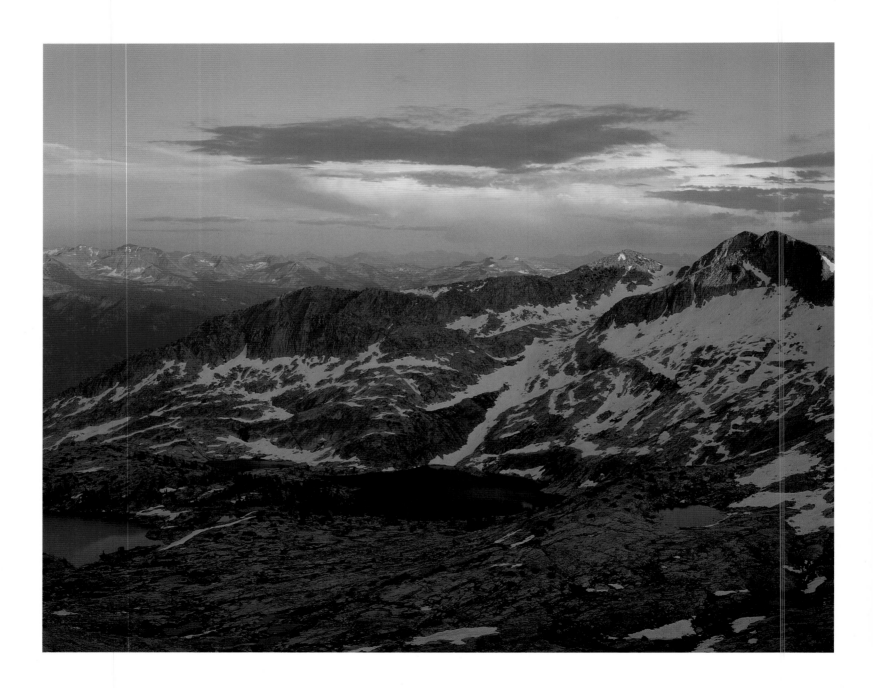

After ten years spent in the heart of [the Sierra], rejoicing and wondering, bathing in its glorious floods of light, seeing the sunbursts of morning among the icy peaks, the noonday radiance on the trees and rocks and snow, the flush of alpenglow, and a thousand dashing waterfalls with their marvelous abundance of irised spray, it still seems to me above all others the Range of Light, the most divinely beautiful of all the mountain-chains I have ever seen.

JOHN MUIR, *1894*

Lake basin north of Tunemah Peak, White Divide KINGS CANYON NATIONAL PARK

The sun came out and flooded all the landscape with liquid gold.
I sat alone at some distance from the camp, and watched the
successive changes of the scene—first, the blazing sunlight
flooding meadow and mountain; then the golden light on moun-
tain peaks, and then the lengthening shadows on the valley; then
a roseate bloom diffused over sky and air, over mountain and
meadow. Oh! how exquisite! I never saw the like before. Last,
the creeping shadow of night, descending and enveloping all.

JOSEPH N. LECONTE, *1875*

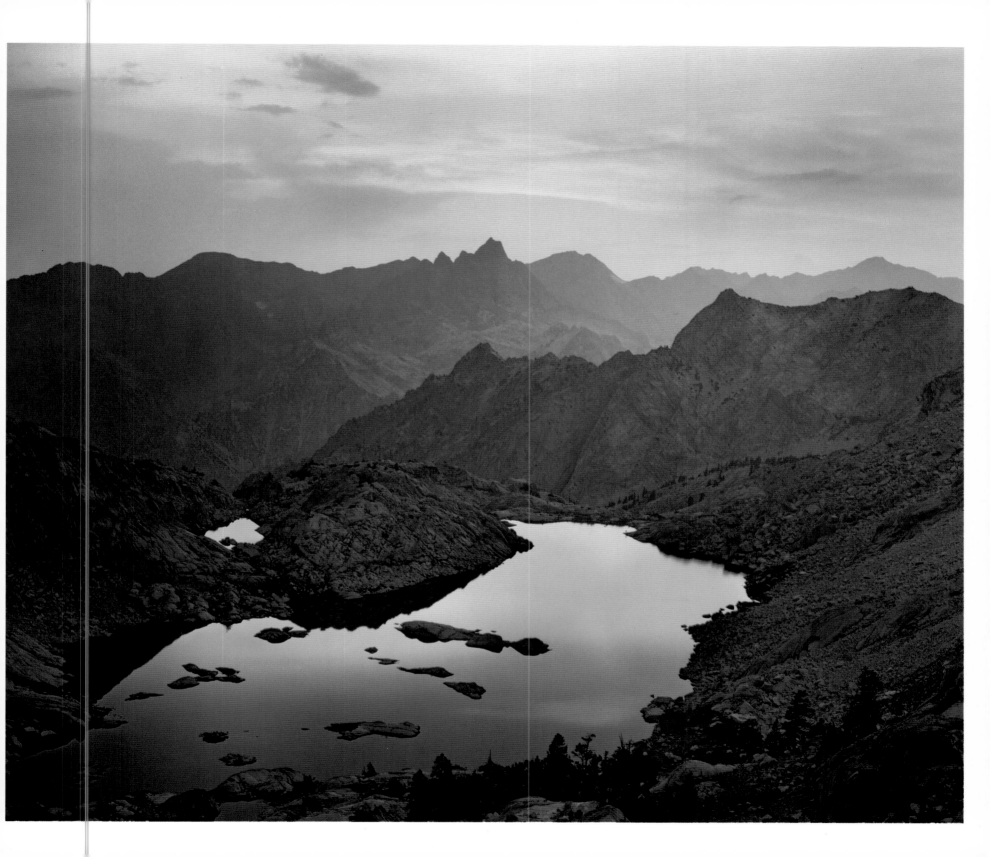

72

And what a spell the forest weaves for you when you are
alone! Each turn of the trail has its message. The little
woodland creatures, the birds and squirrels and chipmunks,
so suspicious of the sound of laughter and voices, look at you
with their quick, bright glances and hardly seem to think it
worth their while to hide. After all, these are the moments
which live. The grandeur of the summit peaks thrills you into
awed stillness while your eyes behold it, yet, like remembered
music, when the image returns to the mind, something of the
stir and the exultation is irrevocably lost.

MARION RANDALL PARSONS, 1905

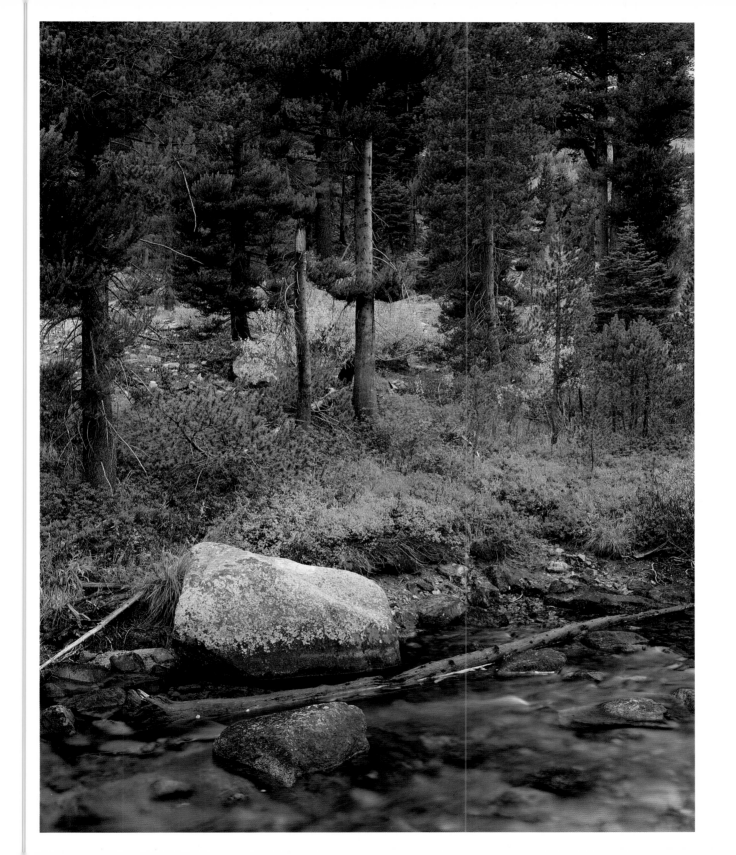

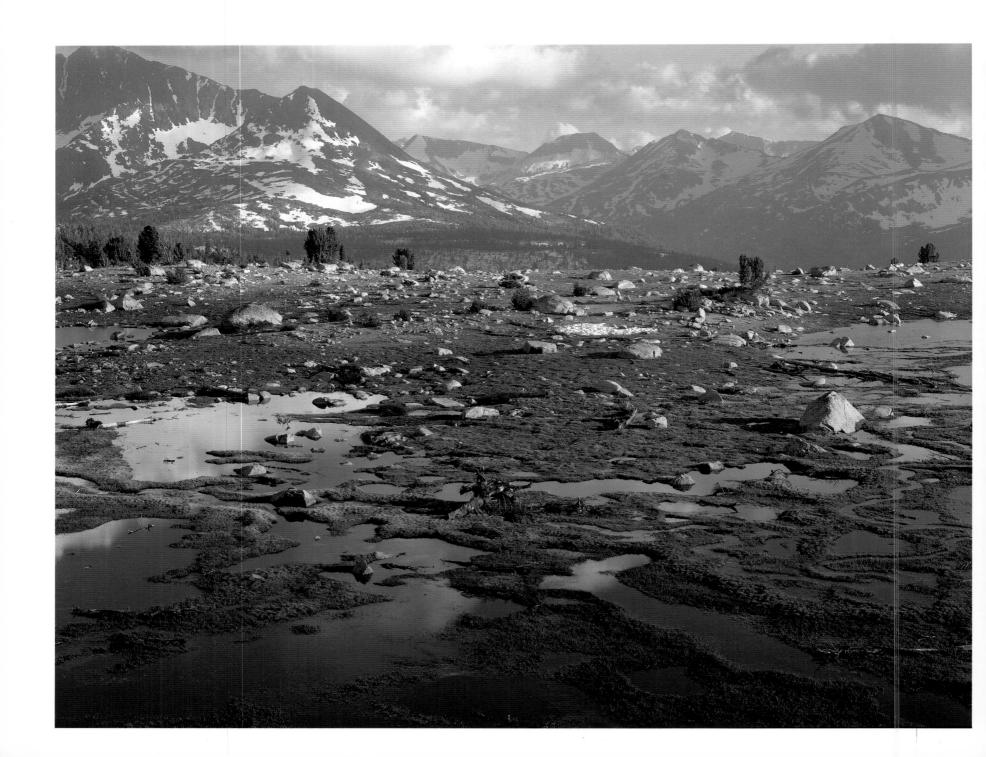

Something will be lost, no doubt, when many pilgrims follow
the mountain trails—when this wilderness, like Switzerland,
is smoothed and carved for the foot of man and dotted with
lodges for his comfort. It must be, and on the whole it is
best; but the facile tourists of the future will be less happy
than we adventurers, who found nature virgin and inviolate,
and braved her beauty and terror in the mood and manner
of the pioneers.

HARRIET MONROE, *1909*

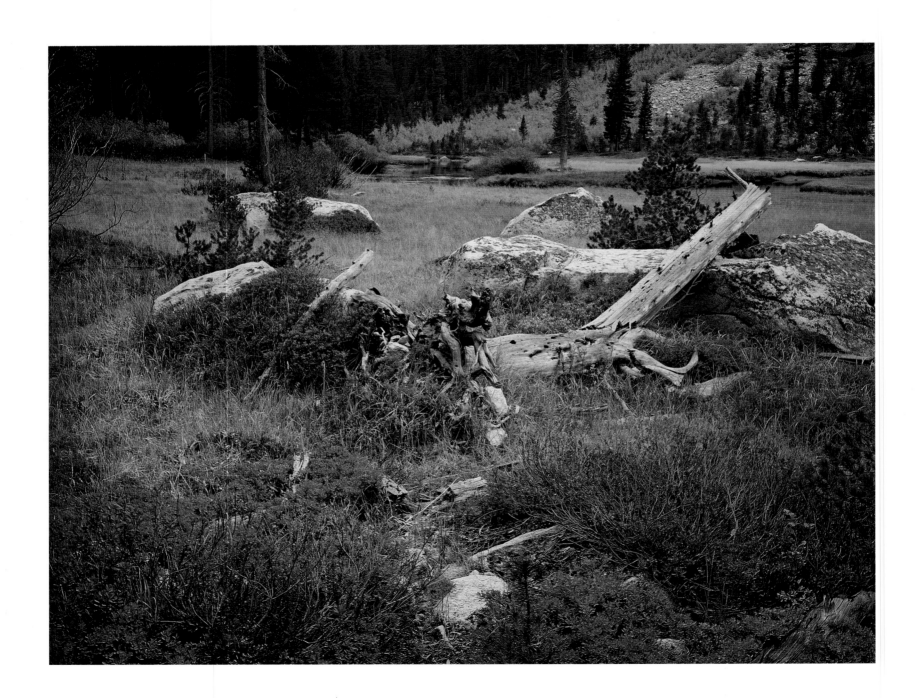

A tree, a rock, has perfect poise and content. There is no
pretending to be anything but itself. In its life, a life enclosing
whole solar systems within the atom, there surely is a
consciousness utterly beyond our comprehension. Some high
emotion embraces everything in time and space, too fine for
language or thought. There is something in the tree, or rock,
of cosmic consciousness, which makes its life infinitely rich.
In the contemplation of this, one begins to doubt whether man
is, after all, the highest form of life.

CEDRIC WRIGHT, *1935*

Autumn in Grouse Meadow KINGS CANYON NATIONAL PARK

We had heard that the King's River was in flood, but I think few of us appreciated what that meant until we first caught sight of the foaming white torrent that raced through the cañon. . . . It was a wicked-looking, dangerous river, full of swirls and eddies and treacherous backwaters whence some passionate, despairing living thing seemed to be fighting to escape. Willow bushes, borne by the force of the rushing waters, barely lifted their straining tops above the current; trees outlining the normal banks stood six feet deep in water; and on one pine fairly in the middle of the stream a large placard gave futile warning of the danger from forest fires.

MARION RANDALL PARSONS, *1907*

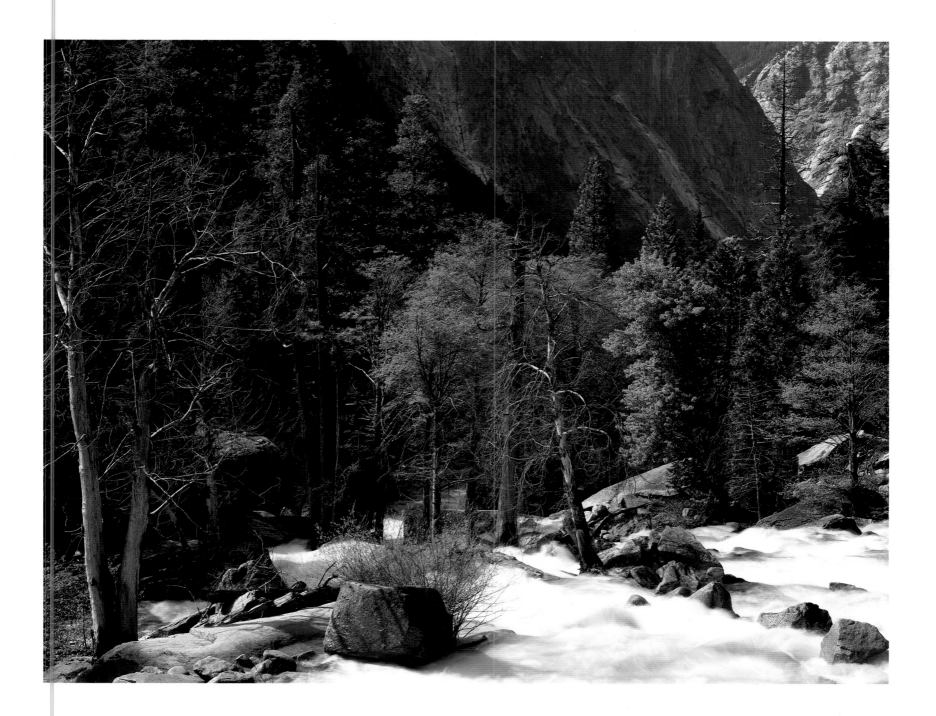

After a pretty wide experience in foreign mountaineering, I find that, as years pass, the Sierra memories are the richest of all in true charm. Nowhere else have I seen the whole conditions of mountain life at once so full of interest and so charged with fascination.

CLARENCE KING, *1893*

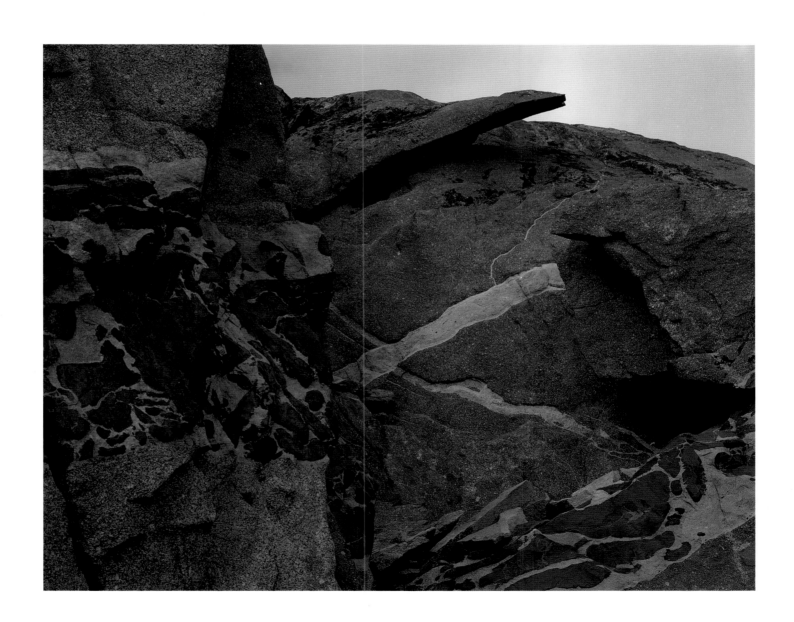

So great was our height, that whole topographies of mountain ranges and wide plains beyond it lay piled up into the sky in level layers, and lost themselves among the immensely remote and hazy horizon. About us, and visibly beneath, stood the compact host of silent, beautiful, restful mountains; snow-spotted, cloud-shadowed, sun-lighted, changing always, yet each in his place changeless since the dawn of primeval time.

BOLTON COIT BROWN, *1897*

KINGS CANYON NATIONAL PARK Mount Clarence King from Window Peak·

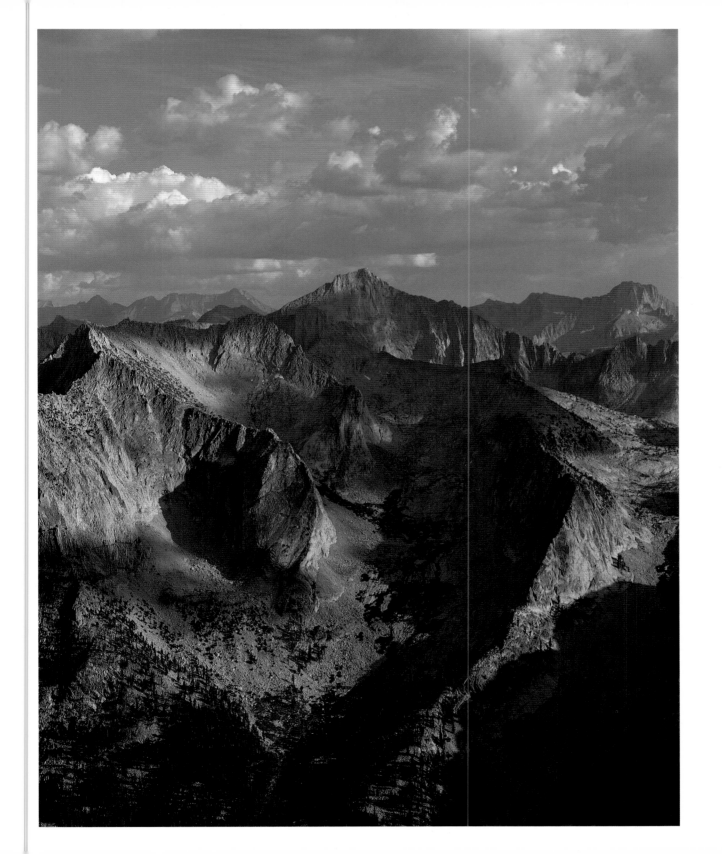

84

One must travel right into the High Sierra before he can gain
an adequate conception of its peculiarly rugged character.
That portion in which head the several branches of the King's
River and the South Fork of the San Joaquin, is the very
climax of the Sierra in loftiness, in wildness, in desolation, in
grandeur of view. Yet each rocky barrier has its vulnerable
point, each pinnacled divide its cranny or gap through which
the mule or jack may be led; and as travel in the Sierra
becomes more general and popular, the route will be worked
out, blazed, and mapped, and yearly traveled by the fortunate
few, until its fame becomes world-wide.

THEODORE S. SOLOMONS, *1895*

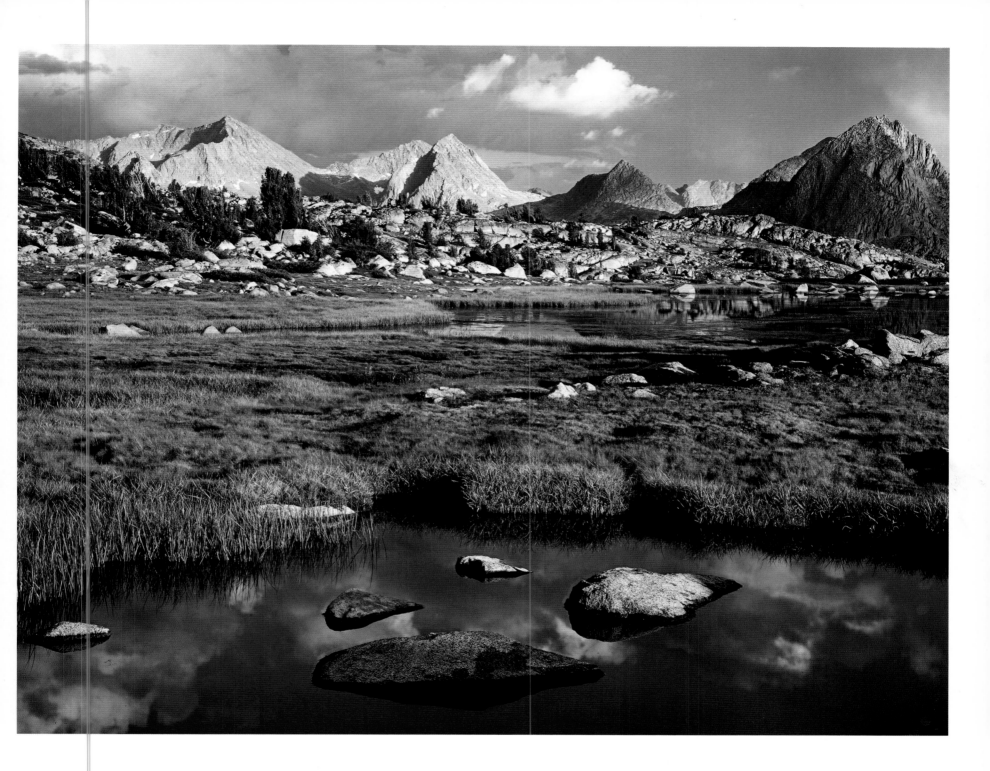

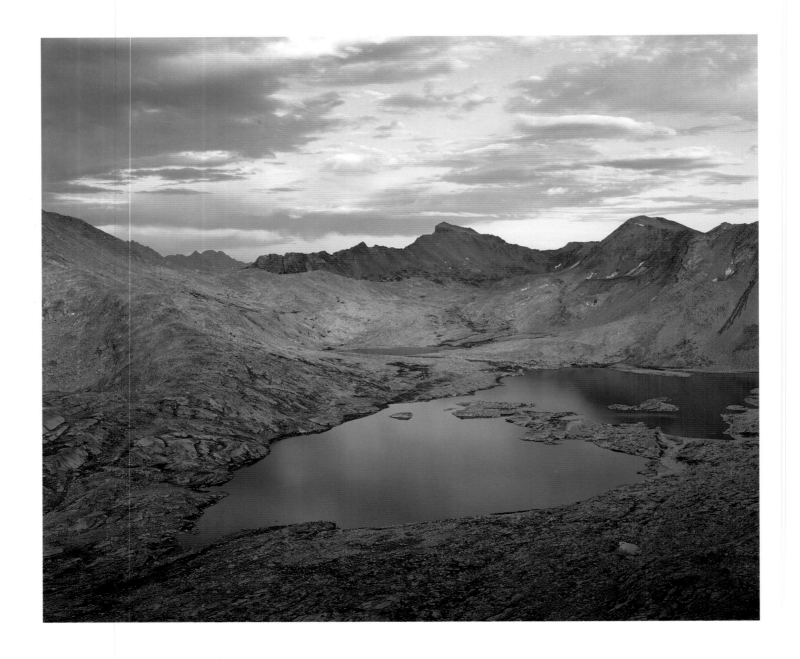

Many large lakes lie in the basin's trough, some few bright with limpid water, others glittering with snow and little icebergs; others still dull with a thick coating of ice that the long siege of the midsummer day's sun is incapable of dissipating. Such is the birthplace of the San Joaquin; such the origin of that river which turns a hundred mills, irrigates a million acres of grain, fruit, and vine, and which imparts fertility and beauty to the largest and richest of California's valleys. The Sierra crest is nowhere grander, and nowhere more generous is the recompense that awaits the weary traveller, than here among the sources of the Middle Fork of the San Joaquin.

THEODORE S. SOLOMONS, *1896*

88

I have sometimes been asked what charm there can be in
the higher levels of the Sierra, when the forests are gone and
nothing remains that is not dead and forbidding, the bare
crags and the snow-fields. To such a question the surest
answer would be an evening spent in such a camp as we had
that night. Such a scene! —wild, desolate, cold, forbidding,
fascinating! White granite for miles, black shadows in the
cañons and clefts, glistening snow, and tiny lakes sparkling
in the moonlight: jagged, fantastic peaks and pinnacles with
alpine intensity of light and shadow, and masses of ice and
snow clinging to the gentler slopes. And withal the intense
quiet and loneliness of the place, a seeming new world on a
new planet, where man and his works are as nothing. The
thrill of it all comes even now, though months have passed,
and will remain through the years to come.

LINCOLN HUTCHINSON, *1903*

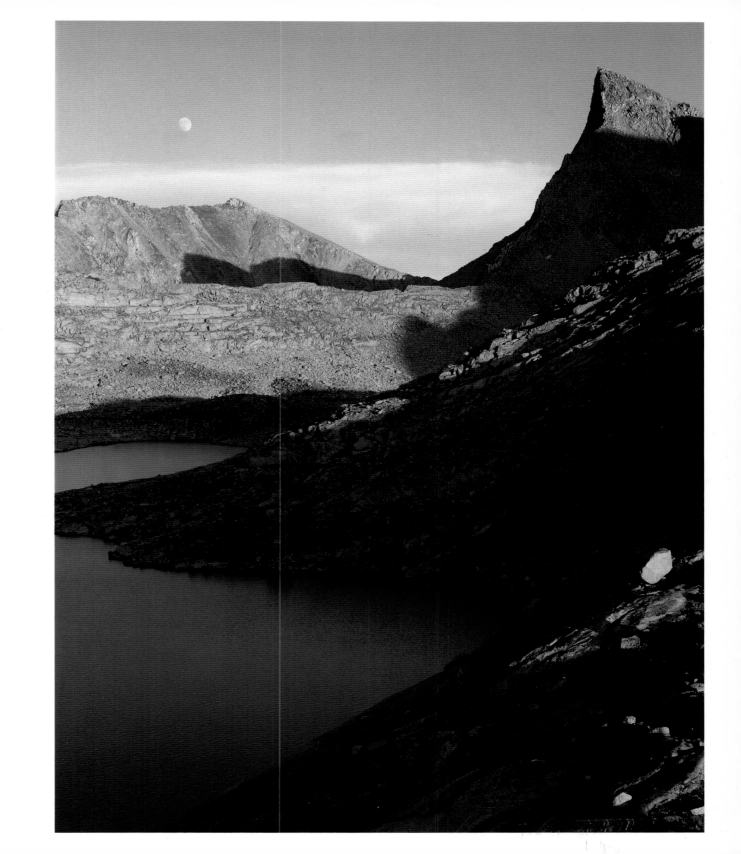

Thank Heaven we have in this great land of ours some of
Nature's manifestations that are worth going to see, worth
preserving for all time, worth cherishing for the good of men's
souls! The time is coming when it will be harder than it is now
to set these great things of the earth aside for the good of all
the people. Every day that fact is brought home to us in our
efforts to restore the beauties of our cities and towns that
have been defaced and almost destroyed in our unthinking
march toward material things.

HENRY H. SAYLOR, *1920*

KINGS CANYON NATIONAL PARK The Black Divide from Dusy Basin

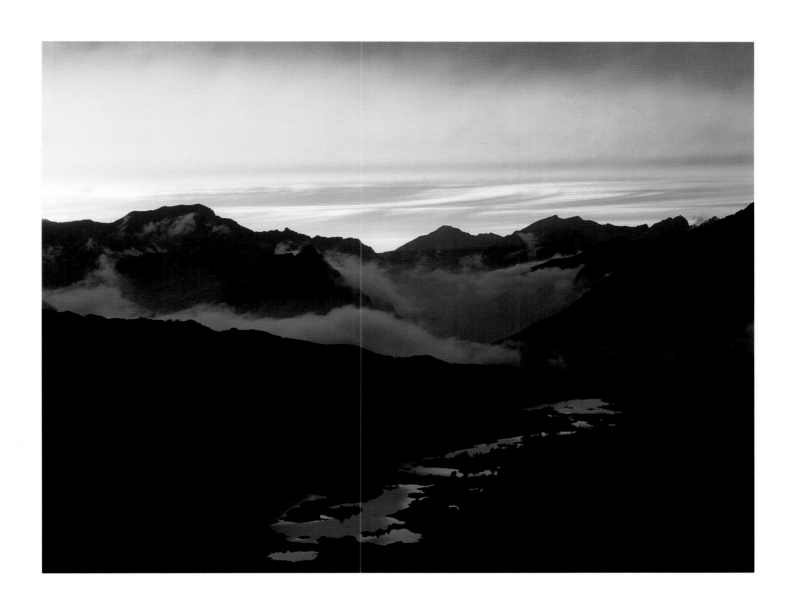

× 11312

MONO CO
INYO CO

NATIONAL

Prospects

BOUNDARY

4WD

Mayfield

Spring

9090

11000

10000

6200

Round Valley
Peak

9000

6400

WILDERNESS

11400

11000

Spring

INYO NATIONAL FOREST

5600

11600

10600

8200

11800

F O R E S T

The great Sierra world was robed in virgin white. Never have I seen a sight so purely

and transcendently beautiful. To feel one's self a mere animal, seeking warmth, food,

and self-preservation; and suddenly, as upon that morning, to be confronted with a

sight that touches to the quick the aesthetic nature, and thrills the immaterial soul

within as it had never thrilled before—what a lesson in the duality of man!

THEODORE S. SOLOMONS, *1895*

EASTERN SIERRA Winter sunrise on Mount Morrison

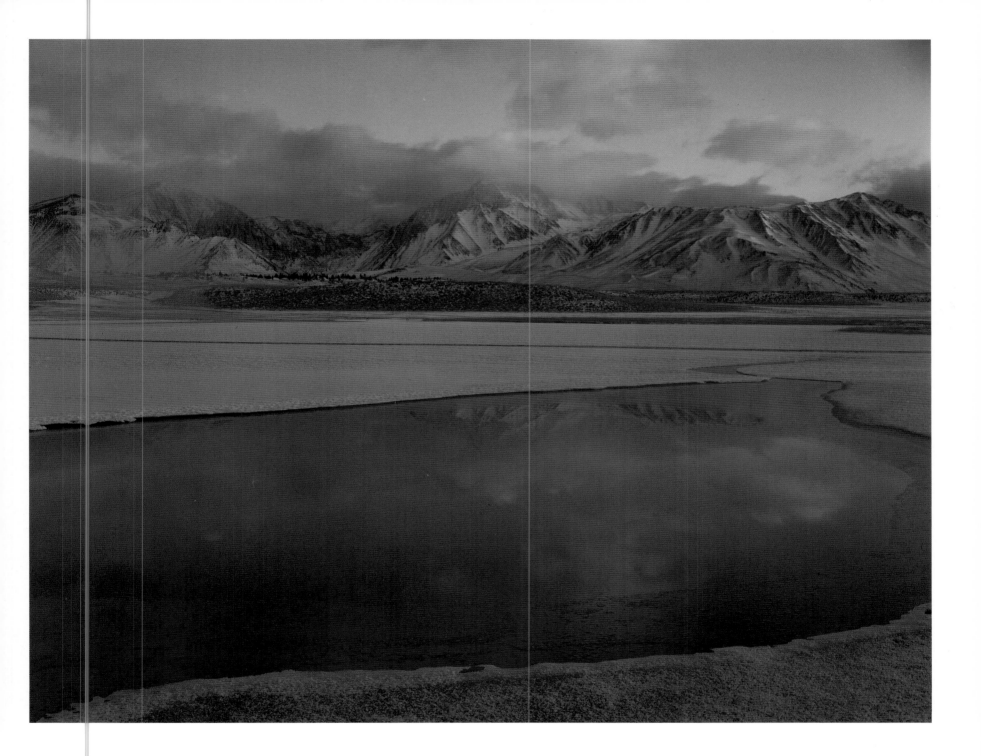

During the middle of the day the thermometer, in the shade, probably remained somewhat below the freezing-point. At night it may have descended twenty or more degrees. The clouds proved false prophets, for not a snowflake fell. Still and sunny were the days—so still you could hear your ears ring—and still and starry were the nights. From the mysterious vast-ness of the fir forest the great owl hooted to the sailing moon, and at dawn the shrill cry of the coyote came ringing over the frozen snow. A woodpecker at the corner of my cabin rapped me up for breakfast.

BOLTON COIT BROWN, *1901*

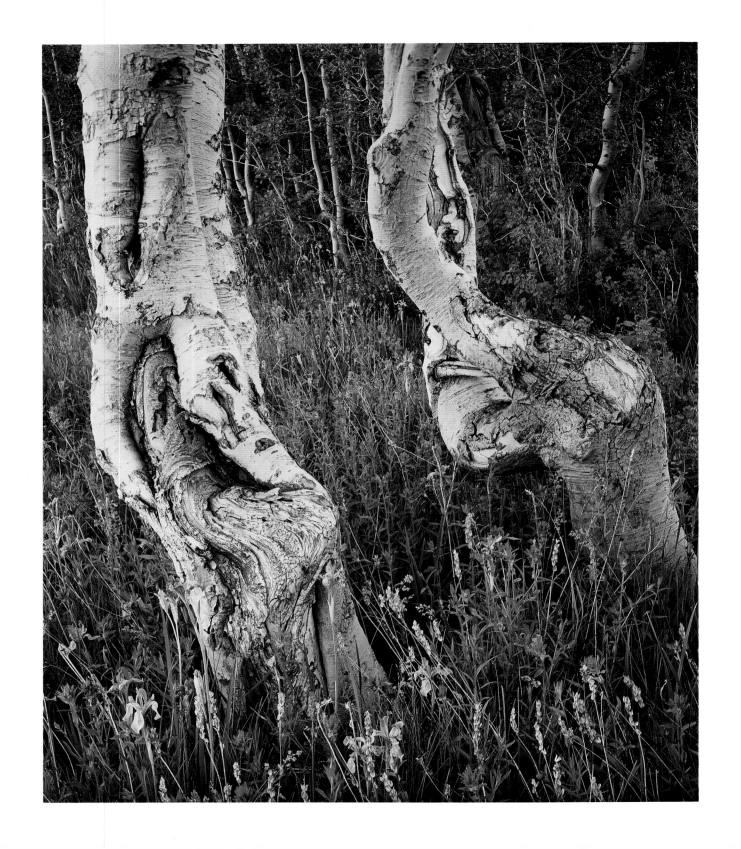

We saw at this camp, in sunny stretches where the snow had melted earliest, the so-called alpine meadows of the brightest, greenest grass crowded full of tall spikes of pink shooting-stars, or dodecatheons. Blue larkspur, a smaller sweet-scented white one, and very tiny yellow, white, and blue violets also dotted the grass. Scarlet and yellow brodiaes, orange tiger-lilies, and in the marshy places pink mimulus and the golden wild musk-plant were plentiful. Now, too, carpets of very tiny flowers appeared in great profusion, each of the millions of small blossoms being a perfect flower no larger than a pin's head. The flora of high altitudes is a perpetual delight and, as we were to find, a calendar of blossoms that varied from spring to late summer, flowering according to elevation and not time of year.

ELLA M. SEXTON, *1902*

The poetic, the artistic, or the scientific mind will find little of
monotony in the Sierra. To say that the landscape in every case
is made up of rock and snow in its loftier parts and of forest and
meadow in its lower is to give no hint of the wonderful fertility
of resource exhibited by Nature, or of her ingenuity in devising
out of the same materials an infinite variety of forms and effects.
It is only the dull or unloving who will find a tiresome repetition;
though it must be admitted that the sense of appreciation of
certain kinds of mountain scenery is often a matter of education.
Even when no other rock than granite is visible and no other
colors than the granite's gray, the white of the snow, and the blue
of lakes and the sky, these landscapes are as varied as form itself.

THEODORE S. SOLOMONS, *1896*

INYO NATIONAL FOREST Basalt formations along Rock Creek

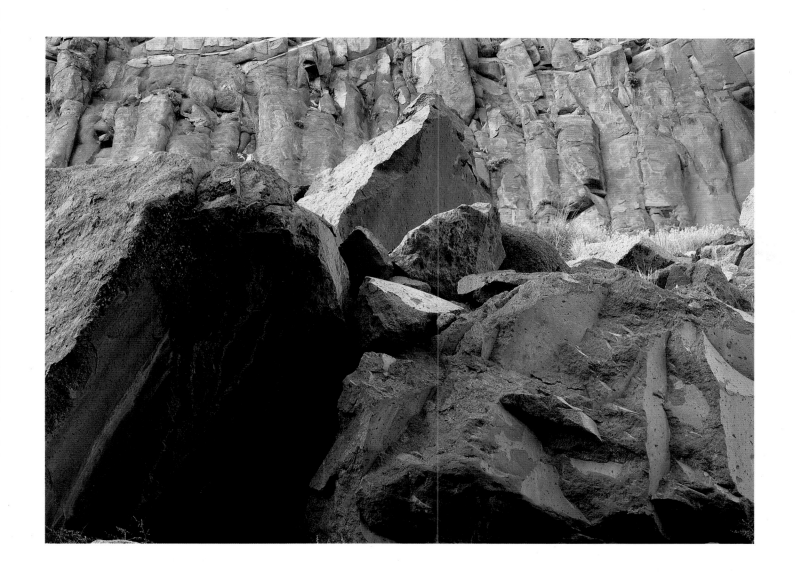

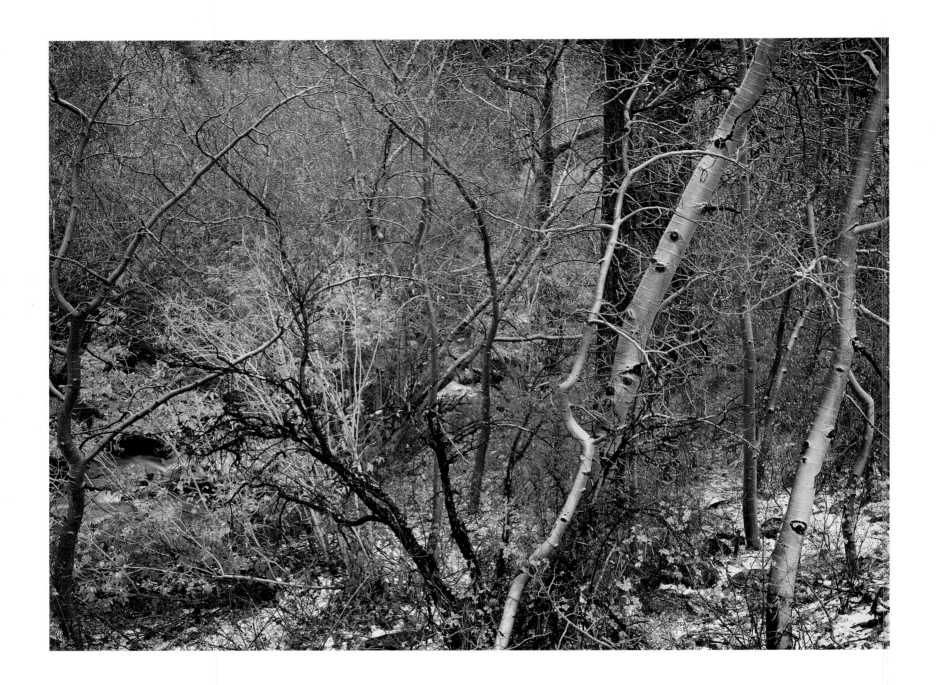

103

Above all, [the Sierra Club's] influence should be thrown toward keeping the parks what they were meant to be—specimens of wild nature used but not "improved" by man. Our members should consider themselves, individually, as so many guardians of the scenery of the west, collectively, as an intelligent mass of public opinion, ready to voice its protest when the well-being of the parks or of areas that ought to be parks is in question. We are nearly two thousand strong now. Double our number and we can more than double our work.

MARION RANDALL PARSONS, *1920*

That ended our mountaineering for the summer. We remained some days longer in the cañon; indeed, we stayed until, notwithstanding that we had had three mule loads of provisions, we were actually starved out. The streams had gone down two thirds, and where six weeks before we had washed the dishes, tall plants grew. The grass plumes held ripened seeds, and in the jungle swamps, tiger lily and columbine had given way to golden rod. As we listened to the music and watched the green swirls of our beloved river, golden leaves—autumn's first—glided by. Then we remembered that life is not all play, and knew the time had come for us to leave this noblest of playgrounds.

BOLTON COIT BROWN, *1897*

It is impossible to ascribe cause for the pure and peculiar happi-
ness one feels in the High Sierra. Of course, freedom from care
and distractions, a natural life in the open, constant draughts
of intoxicating air, are potent. Then, too, for once in one's life
one may be non-competitive, non-acquisitive; a blackened tin
tomato can, a few prunes mixed with dried beef crumbs in a
bandana, a divine scene, the laughter of a friend—these seem to
be the elements of a perfect happiness, refined of circumstance;
happiness having the quality of the sparkle of a mountain
stream, the crystal atmospheric overlay on glittering foliage. . . .

BERTHA CLARK POPE, 1926

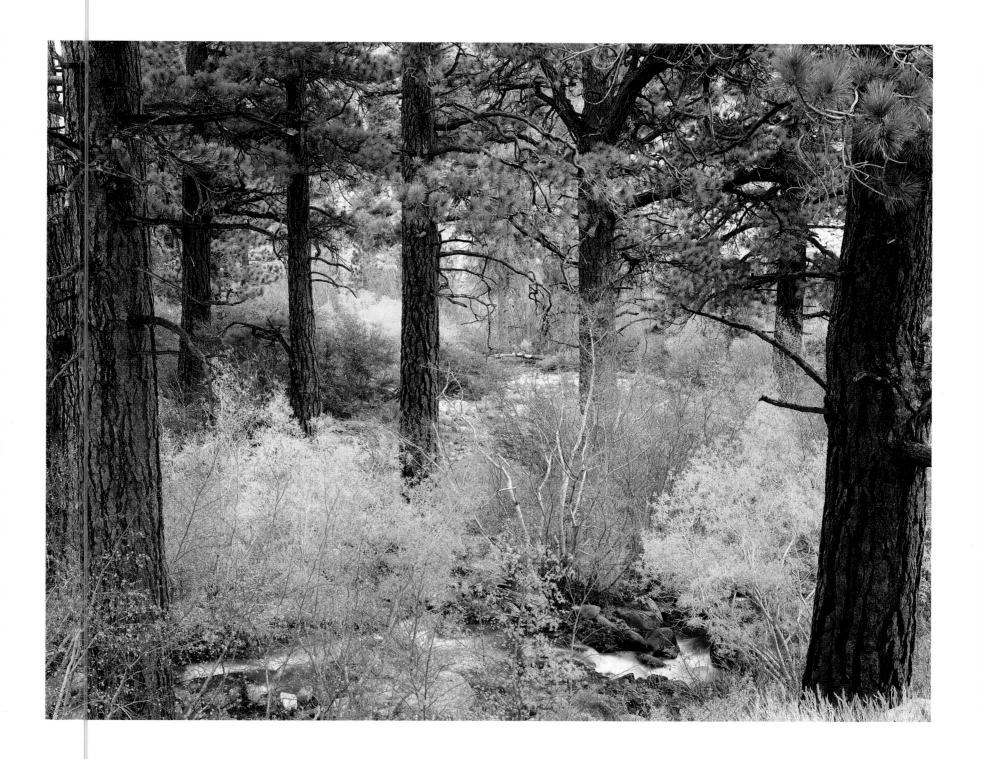

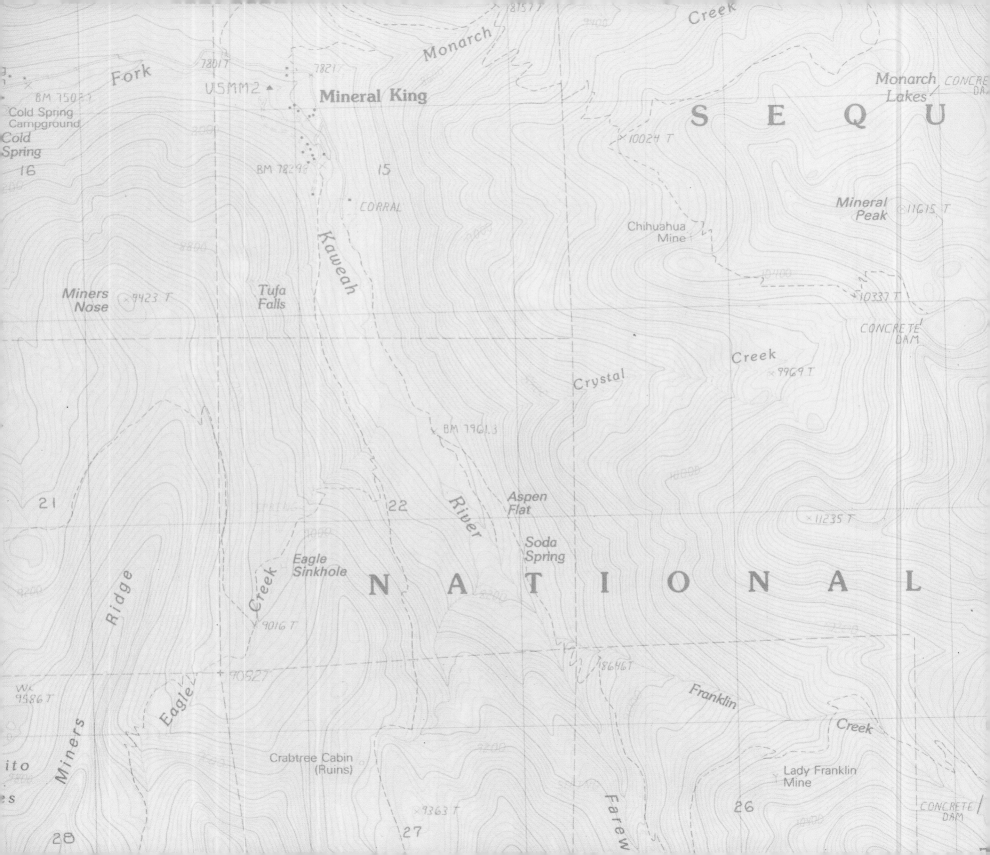

Fork

BM 7503?

Cold Spring
Campground
Cold
Spring

16

7801?

U5MM2

7821?

Mineral King

BM 7829?

15

CORRAL

Monarch

Creek

8157?

9400

SEQU

10024 T

CONCRE
DA

Monarch
Lakes

Mineral
Peak

11615 T

Chihuahua
Mine

10100

Miners
Nose

9423 T

Tufa
Falls

Kaweah

Creek

9969 T

10337 T

CONCRETE
DAM

Crystal

BM 7961.3

9800

21

22

River

Aspen
Flat

Soda
Spring

10098

11235 T

Ridge

Eagle
Sinkhole

Creek

9016 T

NATIONAL

9000

8646T

Miners

Eagle

10527

Wc
9586 T

Franklin

Creek

Crabtree Cabin
(Ruins)

9200

Lady Franklin
Mine

Farew

ito

es

28

9363 T

27

26

CONCRETE
DAM

10400

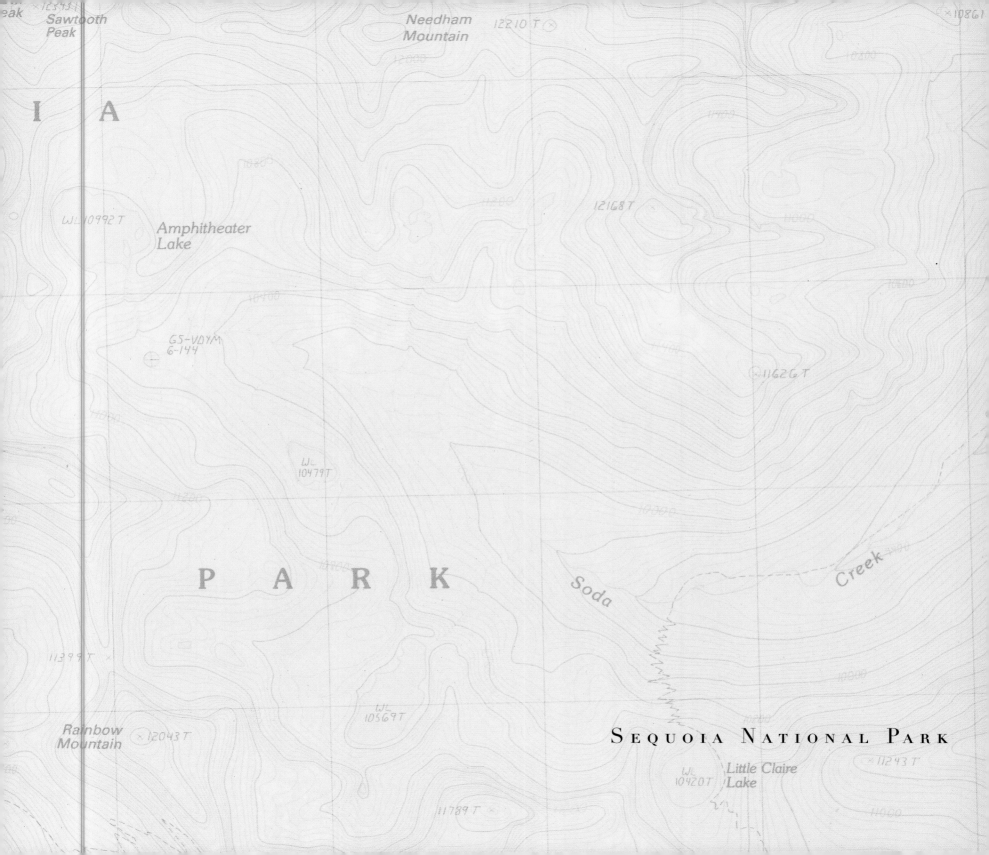

Sawtooth
Peak

×10861

Needham
Mountain

12210 T

I A

×12843 T

12168 T

WL 10992 T

Amphitheater
Lake

GS-VDYM
6-144

×11626 T

WL
10479T

P A R K

Soda

Creek

11399 T

WL
10569T

Rainbow
Mountain

×12043 T

SEQUOIA NATIONAL PARK

×11243 T

WL
10420T

Little Claire
Lake

11789 T

We must save the heart of the Sierra while we may. Always there stretches out to us the beckoning finger of the unattainable. The Yosemite, the Yellowstone, Glacier Park, even the recently remote Tuolumne Meadows, unrivaled in their different appeals, already are becoming crowded. He who learns to know them wants to go on beyond, along the harder, untraveled paths. Solitude, that greatest healer of the soul of man, is his great necessity. He will, he must, have the place where it may be found, and that place is, and will remain, the High Sierra.

HENRY H. SAYLOR, *1920*

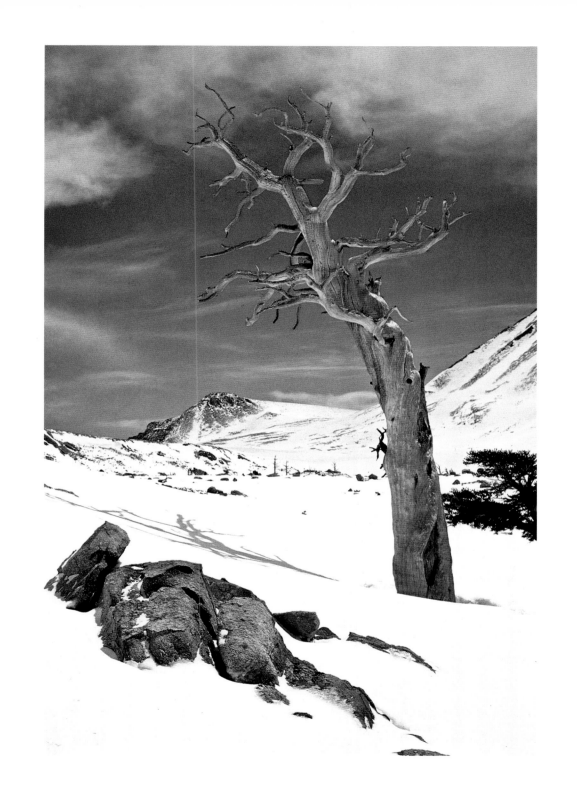

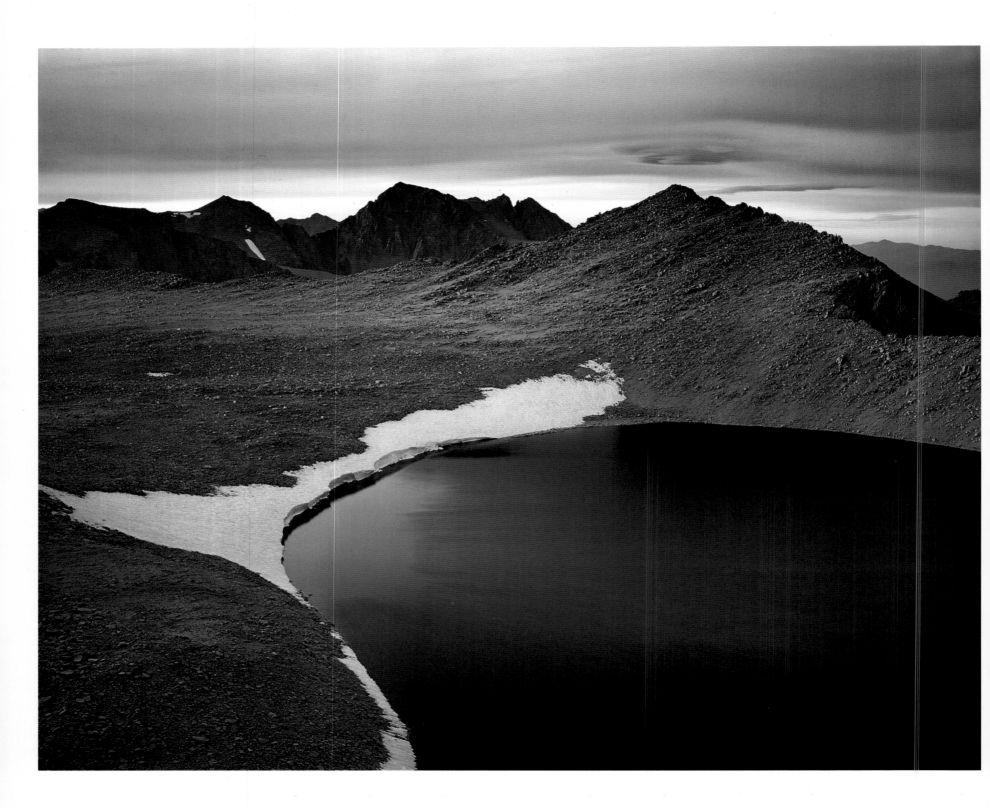

Turning eastward, I gradually ascended the stream and
passed through the upper glaciated basins until I reached
Tulainyo Lake, at an altitude of 12,865 feet above sea-level.
This is unique in its location upon the very crest of the range,
with no apparent outlet. It is almost circular in form, about
half a mile in diameter, and possesses an air of remoteness and
isolation not often encountered. Seldom has human foot trod-
den its almost vegetation-less shores from which rise abruptly
several granite peaks, the highest of which is Mount Russell.

NORMAN CLYDE, *1927*

Few places in the whole Sierra Nevada can have superior
charm to this great basin, with its numerous lakes, its rugged
cliffs, its many easy climbs, and its tough old mountains—
Milestone, Thunder Mountain, Table Mountain. Here were
alpine lakes and streams teeming with fish for the ambitious
angler, sheltered lakes for swimming, colder lakes for heroic
divers, and gushing streams filled with snowy waters.

HOLLIS T. GLEASON, *1933*

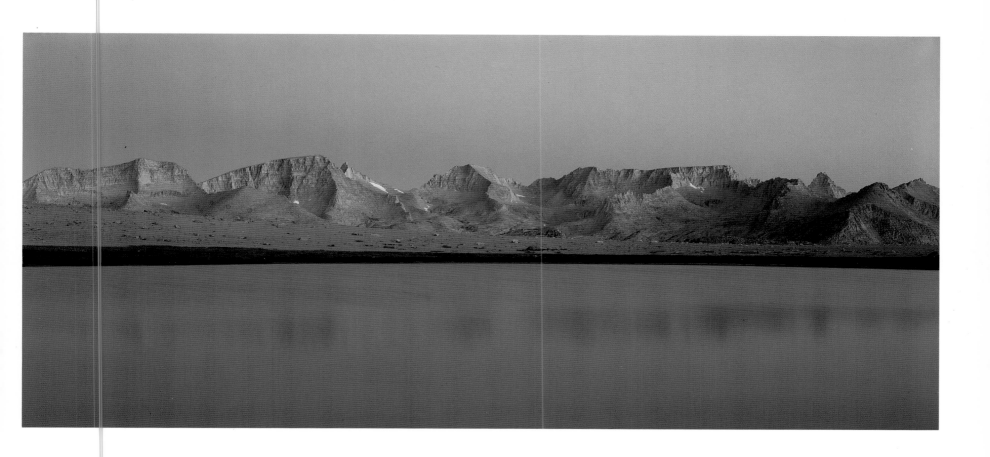

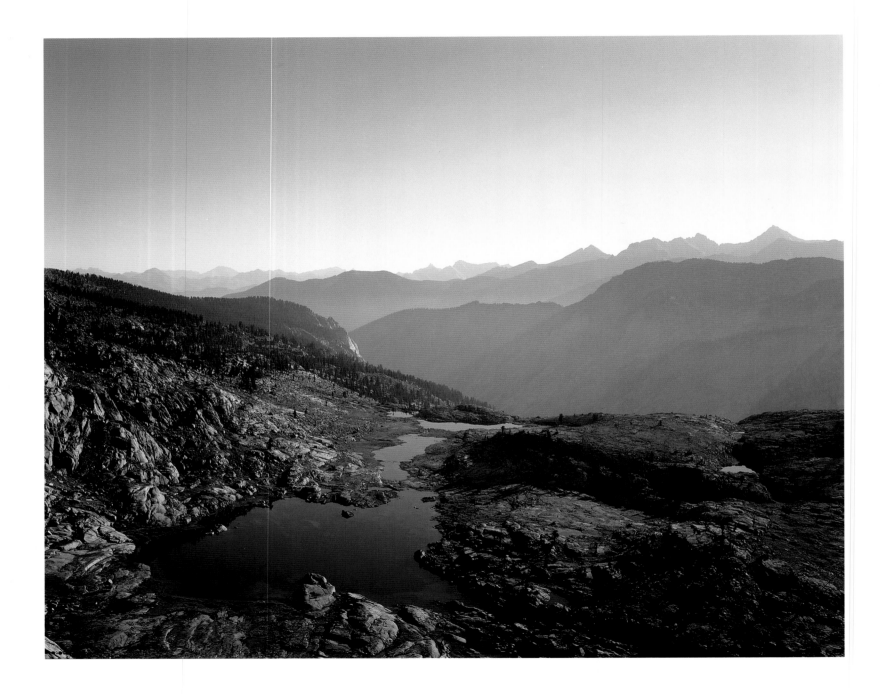

Much of the charm of the mountains depends upon the absolute harmony of all that is there. There is no intrusive foreign thing in them; there is no inappropriate thing; there is no vulgar thing. They do not insolently thrust in your face silly placards about Hobson's Rat Poison or Johnson's Pills; they do not disfigure themselves with lying real-estate signs; the names of no political candidates insult the trees; there are no yelping curs, blatant voices, or jangling street-cars; there is no odor of underground horrors or discomfort of dirty crowds. In the mountains all is large, quiet, pure, strong, dignified; there all is beautiful; each thing is a perfectly appropriate part of that unity which we call nature. . . .

BOLTON COIT BROWN, *1897*

Deadman Canyon from the Tablelands SEQUOIA NATIONAL PARK

The value of the Sierra lies in its being what it is—a region of marvelous scenic beauty, moderately difficult of access. . . . Let us remember that there will always be those who know that the most marvelous views are seen only after physical effort to obtain them, who prefer intimacy with the mountains to their own personal comfort, and who love the smoke of the camp-fire in their eyes and the granite ground upon which they sleep. Let us save a place for them.

ELMO A. ROBINSON, *1930*

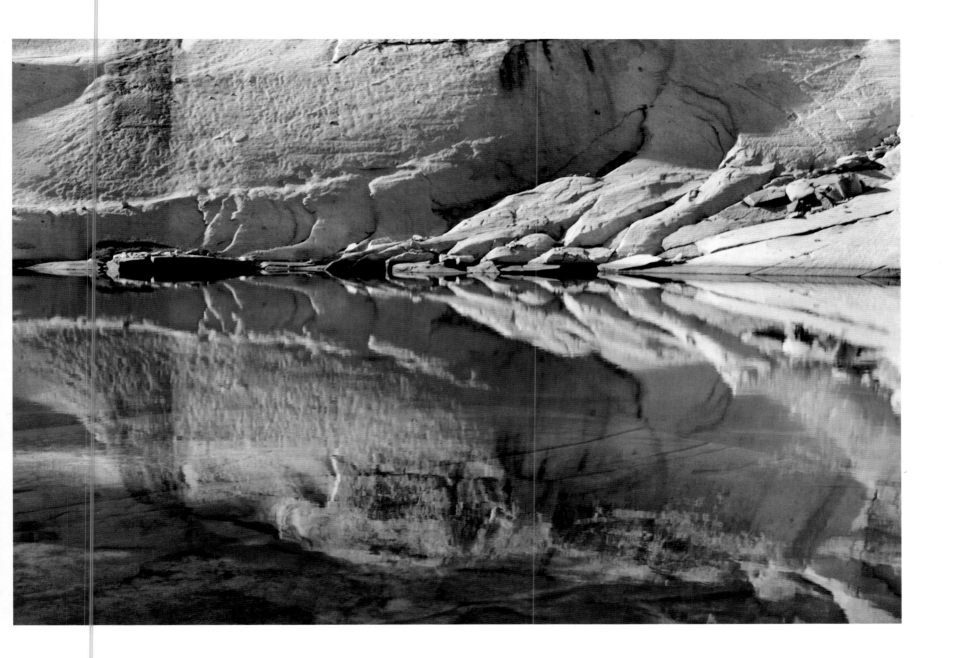

New glories came with the morning, when the Steller's jays, self-appointed alarm-clocks, called the sleepers to witness the first rosy shafts of dawn striking the gray minarets of rock; to watch unseen hands weaving a tapestry of silver and gold down their scarred sides until, amid a rapid and elusive play of spectrum colors, irrepressible waves of light poured over the eastern ramparts, sifted through the trembling pines, and started a new day of joyous life. . . . But one might as well try to paint the sun with charcoal as attempt to describe adequately the beauty and grandeur that filled those charmed Sierran days and nights.

WILLIAM FREDRIC BADÉ, *1904*

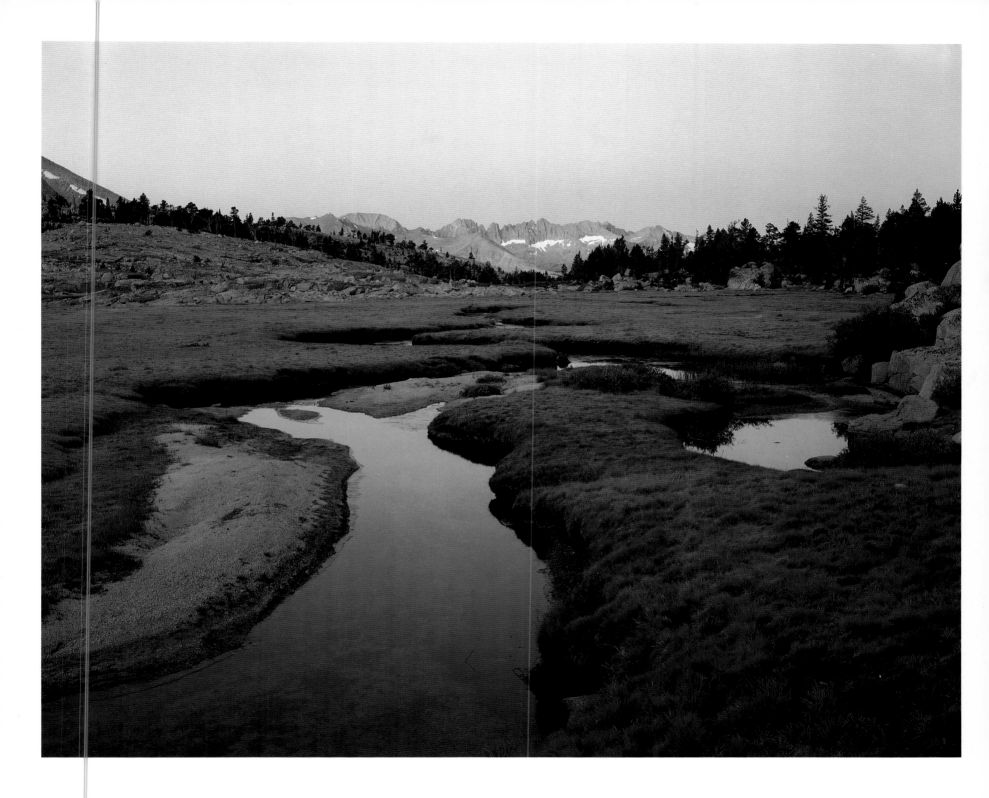

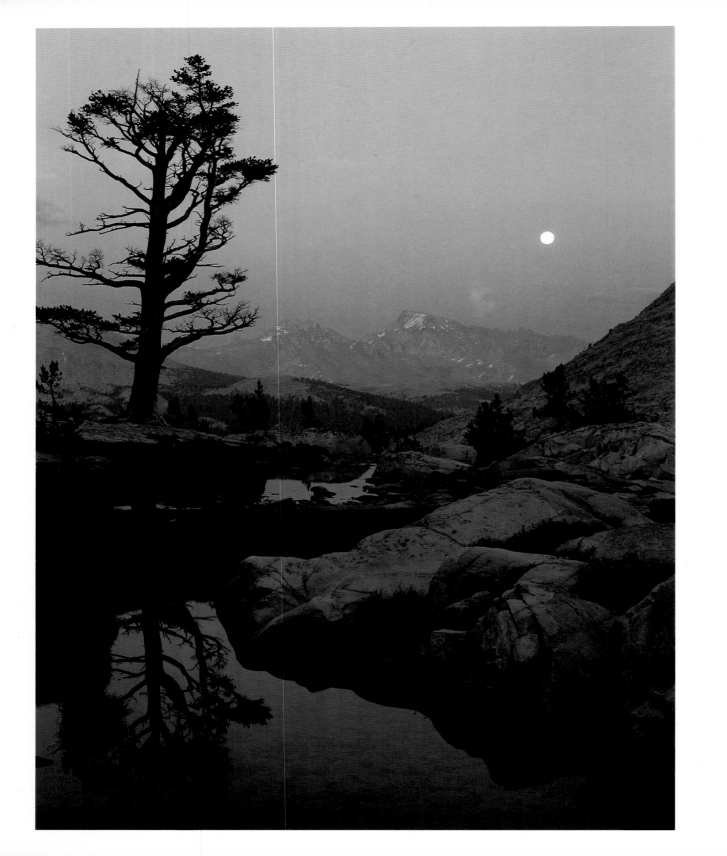

In the evening we walked out on the trail . . . and sat for long under a gracious moon. The sense of detachment that comes upon you in the presence of moon-illumined mountains augments the reality of experience. Space becomes intimate; the world of fixed dimensions fades into patterns of exquisite delicacy, and you mingle your being with the eternal quietude of stone.

ANSEL ADAMS, *1932*

It being late and the snow soft, I ran, going half-knee-deep at
every jump, until my wearied legs collapsed, and I came all in
a heap on my head in the snow. Recovering, I plunged on, and
finished half a mile below in a slide down a long steep slope,
ending just at the edge of a little glacial lake—dark, and
green, and silent. These deep, solitary lakes always give me,
in an especial way, a sense of undisturbedness and complete
isolation—for which I love them. This one was particularly
charming. The vertical rocks that walled it on its mountain
side dropped sheer down and out of sight in its still depths. . . .

BOLTON COIT BROWN, 1895

124

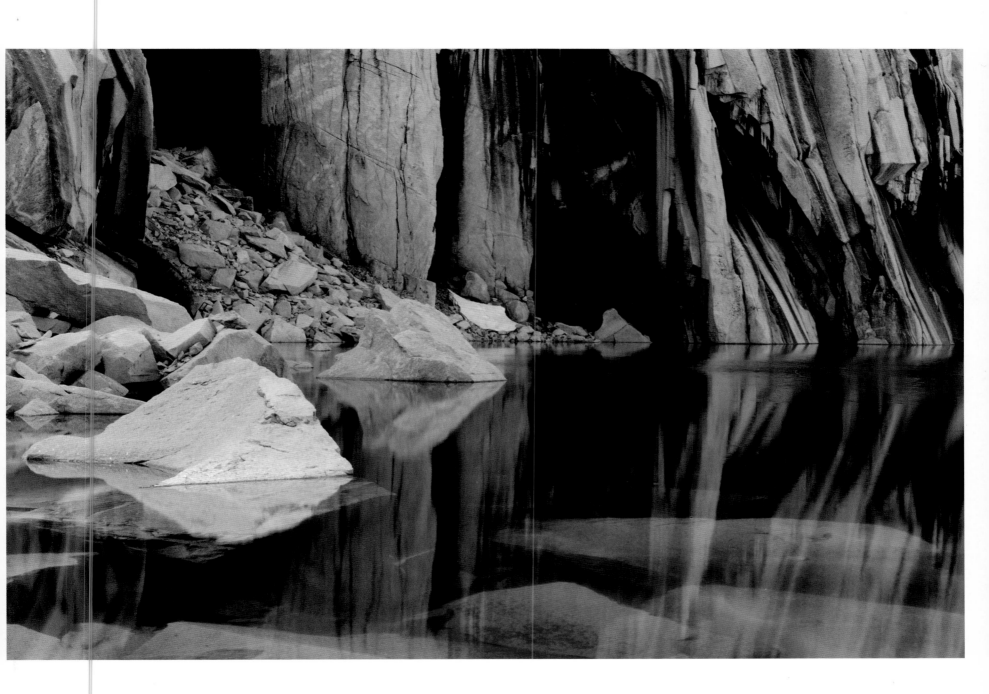

Now came the solemn, silent evening. Long, blue spiky
shadows crept out across the snow-fields, while a rosy glow,
at first scarce discernible, gradually deepened and suffused
every mountain-top, flushing the glaciers and the harsh crags
above them. This was the alpenglow, to me one of the most
impressive of all the terrestrial manifestations of God. At
the touch of this divine light, the mountains seemed to kindle
to a rapt, religious consciousness, and stood hushed and
waiting like devout worshippers. Just before the alpenglow
began to fade, two crimson clouds came streaming across
the summit like wings of flame, rendering the sublime scene
yet more impressive; then came darkness and the stars.

JOHN MUIR, 1894

126

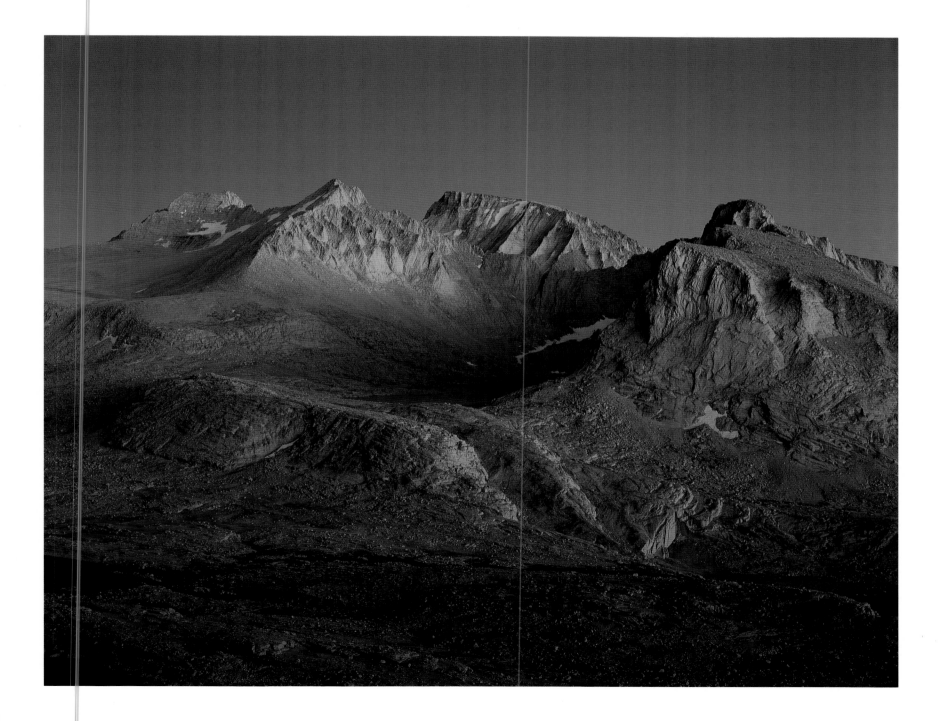

The encircling peaks were barely visible in the dusk, but although their brilliant coloring was lost in shadows relieved only by patches of snow, the imagination imbued them with their familiar hues. The surface of the lake, except when broken by the leaping fishes, mirrored the pageant above. The firmament of stars met the gaze—so familiar, and yet given new brilliance and splendor by the clear Sierra night.

NEIL M. RUGE, *1936*

SEQUOIA NATIONAL PARK Sunset on tarn, Crabtree Creek

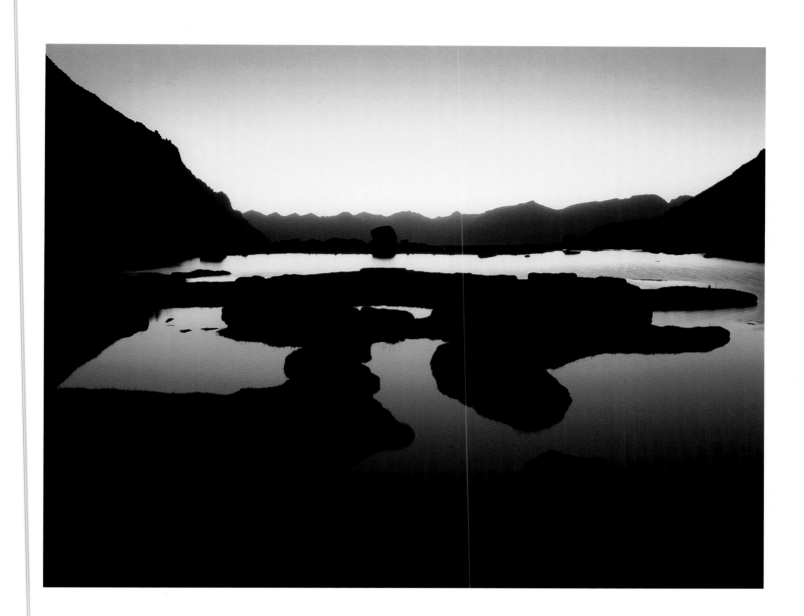

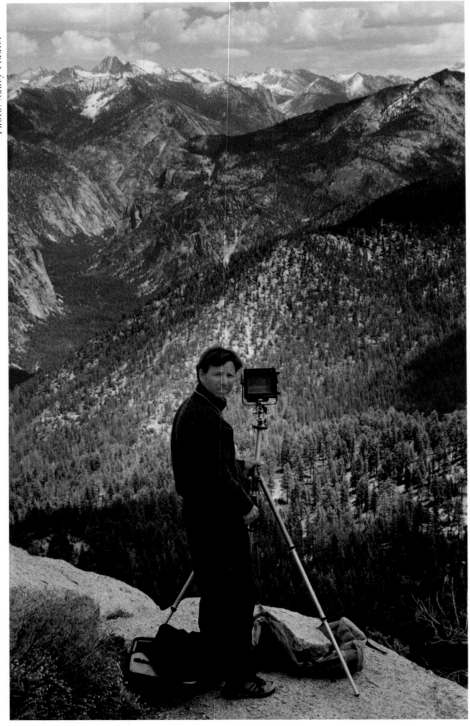

Claude Fiddler on Lookout Peak, Kings Canyon National Park

*I*n the 1970s, I read an article by Sierra climbing and skiing legend Doug Robinson in which he described skiing the John Muir Trail without carrying a stove or maps. I had taken up climbing, skiing, and wilderness travel in my teens, and this article inspired me to take a winter tour of the same trail. My friend Jim Keating and I decided to test our mettle on a skiing trip that would last thirty-three days and travel the length of the High Sierra. This adventure would affect me in a profound way, leading to my becoming a climber and a photographer.

Our trek took us to vistas of indescribable wilderness beauty. At times the mountains would seem to embrace our presence; then Pacific-driven storms would rage at our youthful audacity. We heard the deafening roar of avalanches, a sound that was both terrifying and exhilarating; at other times a winter stillness would surround us for days on end. I found that the mountains brought out more emotions in me than I ever knew I had. They seemed to grab hold of my very soul, and I had the clear sense that these mountains were where I belonged. The direction of my life was clear; I would be a mountaineer, climbing, skiing, and photographing the Sierra Nevada.

I had chronicled our trip on film but was not satisfied with my visual journal. I wanted images that were as strong as my feelings had been during our ski tour. Climbing led to ascents of remote and forbidding walls, sun-ribboned aretes, and airy ridgelines that extended for miles. I drilled bolts on the extreme routes of Tuolumne Meadows and raced the sun on one-day ascents of El Capitan. I loved everything about climbing, but the insights were for me and me alone. Photography, on the other hand, fulfilled my desire to communicate with others. The photographic image conveyed perfectly how I felt when I was in the mountains. So it was photography that led me to explore the vast landscapes, the pristine lake basins, and the lush forests and meadows.

The ensuing years have been filled with demanding study, the advice and tutelage of experts, and the attempt to master the craft of

photography and the kind of concentration that creates good work. The majority of my wilderness trips last from one day to over one month, and I make numerous excursions a year. I do not always follow trail-less routes to remote areas of the range; sometimes a walk out our backdoor can lead to a place that seems to be a long way from anywhere. But it is on the longer explorations into the High Sierra that my thoughts are most clear, and I am able to do my best work. On several occasions I have stood on summits where only one or no prior ascents had been made. In these places of pure wilderness I feel fulfilled, and my camera is my way of recording that experience.

Prior to any trip I spend a great deal of time reading maps and trying to plan possible photographs. Though this process works a majority of the time, I am often surprised to have reality outstrip my imagination. I try to spend at least a couple of days in any one locale. This allows a thorough study of possible compositions, mixed in with peak-bagging and the occasional climb. I am lucky if I find one photograph at any one place; finding two is rare, and I can count on less than one photograph per day on any trip.

Composition is the single most important factor in my photographic endeavor. A photograph needs balance and unity. All parts of the visual image should work together to reveal the intrinsic nature of the subject. The straightforward beauty of the Sierra Nevada is what I find compelling and what I am trying to communicate.

The photographs in this book represent a large portion of my most successful images taken over a fifteen-year period. Some were stumbled on and required some fast action because an exciting quality of light was disappearing. The photograph on page 54, for example, was taken during a diminishing thunderstorm. I could see that the sun was about to break through the cloud cover and wash out the rich colors caused by the overcast sky. The sun also would have dried out the rocks and the water clinging to the primrose and the grasses. I set my pack down and tore through food bags, books, clothes, and so on to get to

my camera gear. I quickly positioned my tripod and attached my camera. (I use a Gowland 4x5 field view exclusively.) I switched from my 150 mm to my 300 mm lens, attached my pack to the tripod center post, and piled rocks onto the pack as ballast. A direct view of the subject required minimal camera movement to achieve focus. Careful framing (eliminating edge distractions while still focusing on the elements of the subject) was my main concern. One exposure at f-32 at one second was all that I was afforded before the sun burned through.

The photograph on page 112 represents the opposite extreme in terms of the time required to capture mood and lighting. I first saw and photographed this composition in 1979, but the light lacked the ephemeral quality that I wanted. This is not an easy photograph to take. The climb to Mount Carillon involves a cross-country elevation gain of 5,000 feet. A high pass near Carillon provides access over the crest, and I have crossed it many times over the years. Each time I hoped to find the perfect lighting. Finally, in 1993, I hiked to my familiar perch to find that an eerie cloud layer had settled over the range. The light of the setting sun slipped under the clouds and softly warmed the landscape. Luckily, for an elevation of 13,500 feet, there was no wind to disturb my exposure, and the contrast range of the subject fit easily on my transparency film. Then I packed hurriedly in the twilight and, as is often the case, hiked back to camp by the light of a head lamp.

Successful and original photographs, and climbs for that matter, come from focus and integrity. Knowing this has kept me devoted to exploring, climbing, and photographing in the Sierra Nevada. Although other worlds of wilderness light will doubtless capture my imagination, I know that none will affect me with the same overwhelming power of that of the High Sierra.

Claude Fiddler,
Crowley Lake, 1995

The Moments in Time Gallery of California is pleased to offer
ten select images from *The High Sierra: Wilderness of Light*,
as fine, limited edition prints. Each print will be hand pulled at
the EverColor lab of California and will be issued with a signed
certificate of authenticity and gallery registry number. For
selection and ordering information please call 800 533 5050.